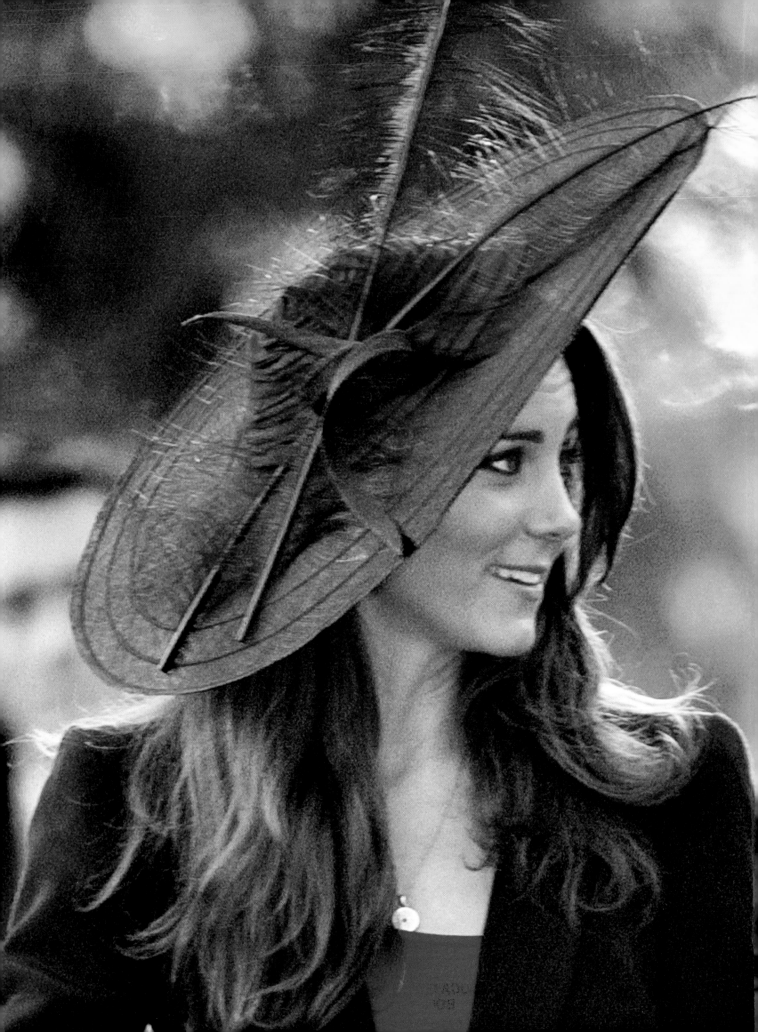

THE ROYAL WEDDING
OF PRINCE WILLIAM AND KATE MIDDLETON

CONTENTS

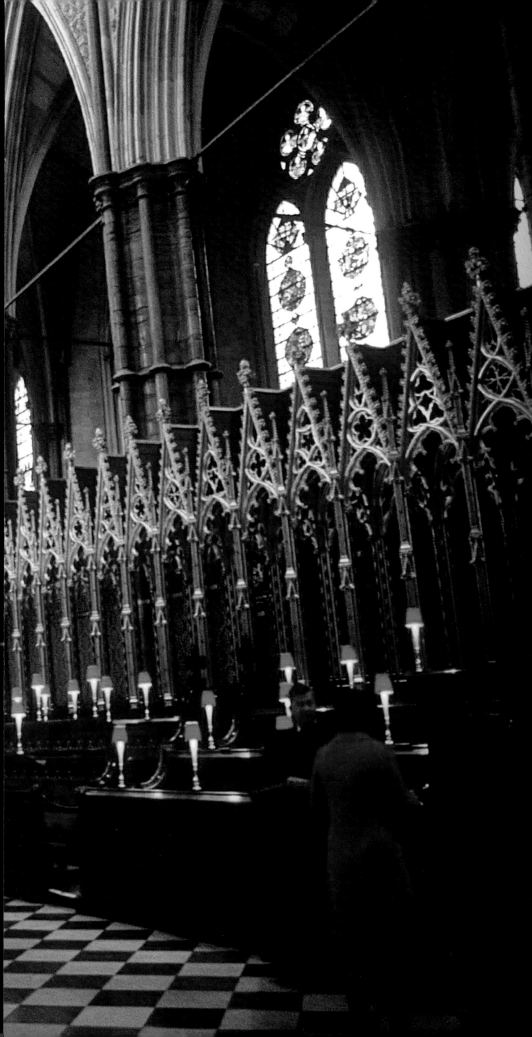

LIFE Books
MANAGING EDITOR Robert Sullivan
DIRECTOR OF PHOTOGRAPHY Barbara Baker Burrows
CREATIVE DIRECTOR Mimi Park
DEPUTY PICTURE EDITOR Christina Lieberman
COPY EDITORS Barbara Gogan (Chief), Parlan McGaw
WRITER-REPORTER Marilyn Fu
CONSULTING PICTURE EDITORS Mimi Murphy (Rome),
Tala Skari (Paris)

PRESIDENT Andrew Blau
BUSINESS MANAGER Roger Adler
BUSINESS DEVELOPMENT MANAGER Jeff Burak

TIME HOME ENTERTAINMENT
PUBLISHER Richard Fraiman
GENERAL MANAGER Steven Sandonato
EXECUTIVE DIRECTOR, MARKETING SERVICES
Carol Pittard
DIRECTOR, RETAIL & SPECIAL SALES Tom Mifsud
DIRECTOR, NEW PRODUCT DEVELOPMENT
Peter Harper
DIRECTOR BOOKAZINE DEVELOPMENT & MARKETING
Laura Adam
PUBLISHING DIRECTOR Joy Butts
ASSISTANT GENERAL COUNSEL Helen Wan
BOOK PRODUCTION MANAGER Suzanne Janso
DESIGN & PREPRESS MANAGER Anne-Michelle Gallero
BRAND MANAGER Roshni Patel

EDITORIAL OPERATIONS Richard K. Prue (Director),
Brian Fellows (Manager), Keith Aurelio,
Charlotte Coco, Tracey Eure, Kevin Hart,
Mert Kerimoglu, Rosalie Khan, Patricia Koh,
Marco Lau, Brian Mai, Po Fung Ng, Rudi Papiri,
Robert Pizaro, Barry Pribula, Clara Renauro,
Katy Saunders, Hia Tan, Vaune Trachtman

SPECIAL THANKS TO Christine Austin, Jeremy Biloon,
Glenn Buonocore, Jim Childs, Susan Chodakiewicz,
Rose Cirrincione, Jacqueline Fitzgerald,
Carrie Frazier, Christine Font, Lauren Hall,
Malena Jones, Mona Li, Robert Marasco,
Kimberly Marshall, Amy Migliaccio, Nina Mistry,
Dave Rozzelle, Ilene Schreider, Adriana Tierno,
Alex Voznesenskiy, Jonathan White, Vanessa Wu

We welcome your comments and suggestions
about LIFE Books. Please write to us at:
LIFE Books, Attention: Book Editors,
PO Box 11016, Des Moines, IA 50336-1016

If you would like to order any of our hardcover
Collector's Edition books, please call us at
1-800-327-6388 (Monday through Friday,
7:00 a.m.–8:00 p.m. or Saturday,
7:00 a.m.–6:00 p.m. Central Time).

PAGE 1: The official engagement portrait, taken
in the State apartments of St. James's Palace on
November 25, 2010.
MARIO TESTINO/CLARENCE HOUSE/GETTY

PAGES 2–3: In October 2010, Will and Kate attend
the wedding of their friends Harry Meade and
Rosie Bradford in the village of Northleach,
Gloucestershire. MARK CUTHBERT/PA

THESE PAGES: Westminster Abbey quietly awaits the
tumult of April 29, 2011. NILS JORGENSEN/REX USA

INTRODUCTION
CINDERELLA, 2011

WITH MOST OF OUR LIFE BOOKS, WE ENDEAVOR to present a pictorial and prose narrative that might appeal to anyone and everyone. Whether we're dealing with plants and animals in *Wonders of Life*, places in *Heaven on Earth* or even the history of monarchy down through the centuries in *The Royals*—to take three recent examples—we begin by assuming there is a general interest in the topic. Who wouldn't want to know or see more about the critters of the Galápagos, the geophysical forces that created the Grand Canyon or the deeds and misdeeds of Henry VIII? Nobody is who.

This book is different. It is not for everyone. This book is for you, and you in particular.

If you are reading this introduction, then we presume you are one of the many people throughout the world who look forward to, and love, a royal wedding. You grew up on *Cinderella* and *Sleeping Beauty*. Your parents read the fairy tales to you at night, and then you saw the Disney versions: at the Strand Theater downtown, or on the Sunday night show hosted by Walt himself, or via a VCR tape, or cleaned up on a deluxe, remastered DVD. Today, perhaps, you are reading *Cinderella* to your own children.

If we were to do a LIFE book on the history of the Super Bowl, we would keep sports fans in mind. As we are doing a book on the royal wedding of Prince William of Wales and Catherine "Kate" Middleton, we know full well that we have romantics—and "royals watchers"—in the audience.

This is good, as we fancy ourselves romantics as well. Love stories appeal to us. They make for lovely, happy, emotion-filled pictures and for equally lovely stories to tell: the moment the prince popped the question, the moment the future princess said yes. In the end, there is the pomp and circumstance, the splendid color of it all filling the page. Putting together a book like this equates to third-grade recess: pure fun, nothing but smiles.

In the classic version, and in the Disney, Cinderella was swept off her feet by Prince Charming . . .

But of course we also want to tell you a few things.

Do you really know the Windsors? The family from which the attractive Wills, as he was called endearingly by his mum and dad, descends? This saga is not just Charles and Di and Elizabeth II; this is *The King's Speech* and even longer ago, all the way to Victoria. Do you know anything at all about the Middletons, an up-from-the-bootstraps British clan from the hinterlands that is only now learning to bow and curtsy properly in Buckingham Palace? There's a love story there, too: a husband and wife with working-class roots forming an upwardly mobile family with three children who not only get along but are devoted to one another.

And then, finally, there are Will and Kate. They are the ultimate gift for Cinderella devotees: a true prince and a certified commoner. A coach and horseman to take them from church to palace, for goodness sake. Straight from the page!

This is a perfect story in ways that even the nuptials of Charles and Di, "the wedding of the century" 30 years ago, were not. William (or Will, or Wills, depending on how well you know him) has spent his life in the public gaze and has shown himself to be an exemplary boy, student, young man and, now, an officer and a gentleman. Kate has been by his side for such a

sufficiently long time that we have come to know her as not just lovely but smart and spirited. Seven hundred and fifty million people worldwide watched on television as Diana walked down the aisle of St. Paul's Cathedral in London on July 29, 1981. The numbers aren't in yet on how many will attend as Kate proceeds so beautifully at Westminster Abbey on April 29, 2011, but the widespread affection for this couple, and the good wishes, can be premeasured.

In the pages that follow, there are rarely seen pictures and superior renderings of familiar scenes from the past several years. We at LIFE Books routinely brag on these things—but, again, not this time. There is no need. This is a simple book to explain. It is a volume of joy and celebration, a book that is all about royal weddings (today's wedding, and others from history, around the world) and about this handsome young couple.

It is a book for you.

And for Will and Kate.

Felicitations!

. . . And in the modern day, the same thing happened—and the 1902 State Landau awaits to transport the newly wedded couple from Westminster Abbey to Buckingham Palace on April 29. This coach is not, however, derived from a pumpkin.

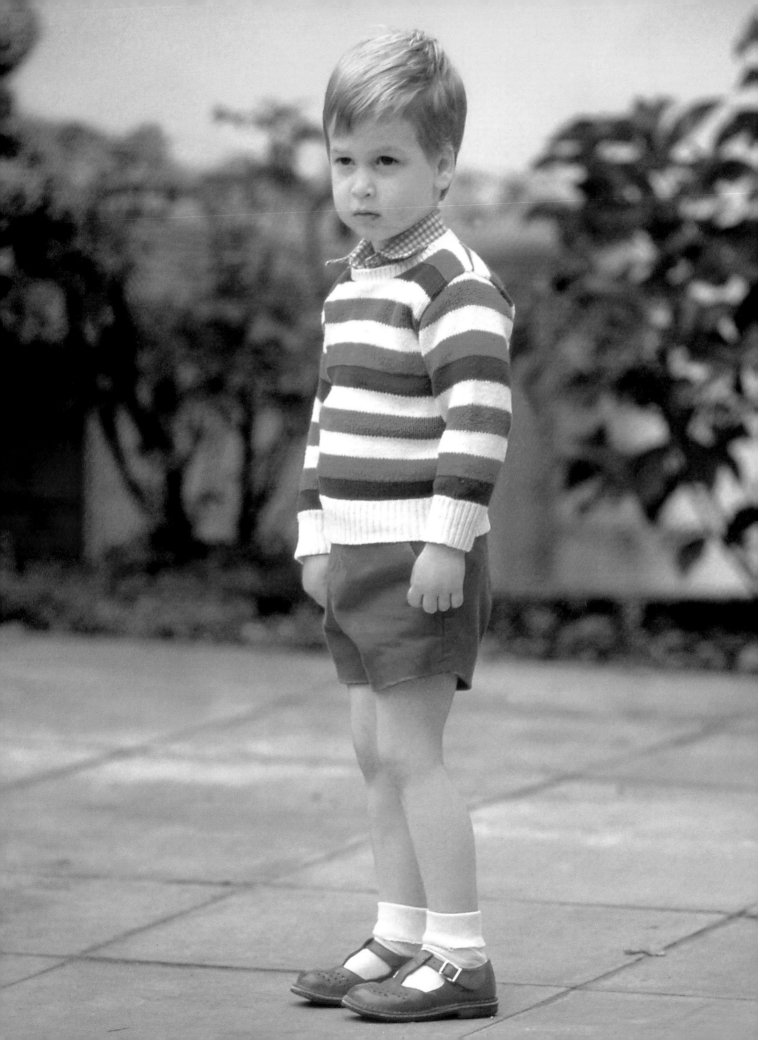

I | THE PRINCE

IT COULD WELL BE THAT THERE IS NO OTHER LIFE ONE MIGHT BE BORN into that is, from delivery to the grave, so very public—open to the scrutiny of the masses; owned, in an intensely proprietary way, by "the people"—as the life of an heir to the British throne. American Presidents leave office after a while and their kids can seek a semblance of normality. The children of celebrities are interesting to the public largely to the degree that they, too, seek the limelight. But a prince or princess will be watched and judged, often unfairly, every step of the way, day after day, dawn to dusk.

Foibles and faults will be laid bare at every turn, and therefore we must assume that William is an exemplary young man, one deserving of the love of such a fine young woman as Kate. The rap sheet on Will is less than lean; it's nonexistent. If it is too much to say that he is flawless, he is, generally speaking, faultless. And, by all accounts, he's a good guy to boot: fun, funny, generous, gregarious, smart, loyal and brave, clean and reverent. Pretty close to a perfect prince.

William Arthur Philip Louis of Wales was born on June 21, 1982, to Prince Charles and Princess Diana, the former Diana Spencer, known best throughout the world as Lady Di. Will's paternal grandmother is Queen Elizabeth II, and the infant was immediately second in the line of royal succession to the throne behind his father, a status he retains today. The boy was known in his family as Wills or, sometimes, Wombat. As would also be the case with his kid brother, Harry, William, though close to his father, was his mother's son. Diana chose his name, dressed him, planned his birthday parties and play-dates, selected his schools and tutors, took him to McDonald's to lend his boyhood a bit of ordinary life and to homeless shelters in order to educate the boy in civic responsibility. The kind of proactive mothering Diana displayed was unprecedented in royal history—hitherto a

His mother, Diana, loved this brilliant sweater, which William wore on his first day of school— an event that of course brought out the cameras.

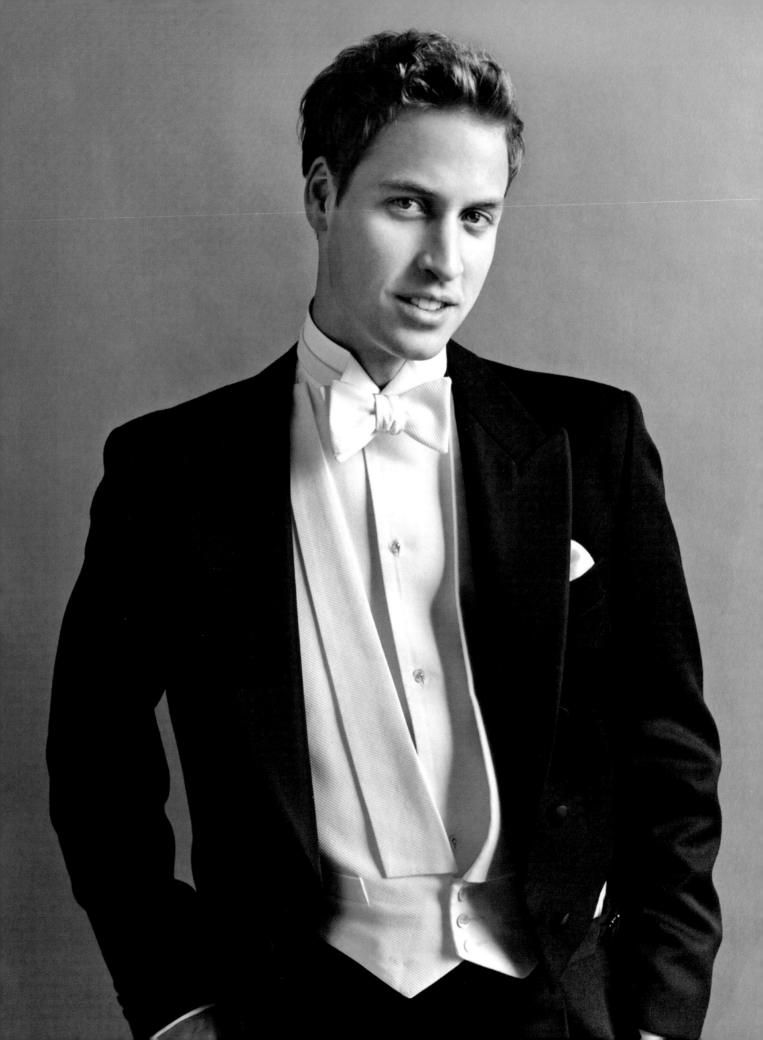

royal child was chiefly under the care of staff: nursemaids, nannies and governesses—and when she and Charles divorced in 1996, there was little doubt that her sons would continue to be principally raised by her at Kensington Palace in west London.

A handsome adolescent, Will was something of a royal rock star, a role he played with chivalry. He toured the world representing the monarchy, behaving with great grace and maturity. Of the two brothers, it was William who was a dutiful and successful student, and he gained admittance to Eton College and then to the equally august University of St. Andrews in Scotland. There he earned a Scottish master of arts degree with upper second class honors in geography, the highest marks ever achieved by an heir to the British throne. At St. Andrews, Will met and fell for his fellow student Kate . . . But we will arrive at the romance soon enough.

The shocking, devastating episode in William's and Harry's lives was, of course, the death of their mother in a 1997 car accident. The whole world mourned Diana grievously, and opened its arms in sympathy to the boys. Yet again, William's comportment was exemplary. Although in anguish, he reached out in turn and sought to comfort his mother's devotees who had made pilgrimage to the gates of Kensington. Throughout the terrible ordeal, admiration for the prince only grew.

And that growth continued when, upon graduating from university, he embarked on a military career. He has since extended his original enlistment and is today a flight lieutenant in the Royal Air Force.

During all of this, he was watched. The Palace pled for the press to leave him alone at Eton; his mates at St. Andrews went along with his alias, "Steve," in hopes of shielding him from prying eyes. But none of it worked perfectly, and at the end of the day, none of it really mattered. The photographic record of the prince's life only confirms the public perception: This was a good kid who has now become a fine young man. The reason people the world over grew so excited about the impending nuptials of Will and Kate is that they have liked Prince William for a long, long time. Ever since, in fact, the day he was born.

The handsome William poses in St. James's Palace for a formal portrait to be released on the occasion of his 21st birthday, June 21, 2003.

THE BIRTH OF A PRINCE

Right: Princess Diana is expectant as she attends a polo match in 1982; the happy parents (bottom) after William is delivered at St. Mary's Hospital in London. Below: The birth certificate. Opposite: A formal portrait of mother and child made by Lord Snowdon, who is something of a house photographer at Buckingham Palace as he was the husband of Queen Elizabeth II's younger sister, Margaret.

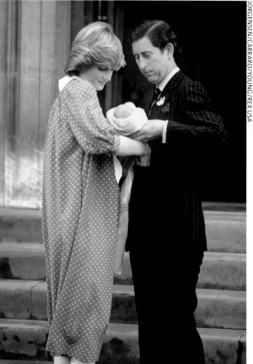

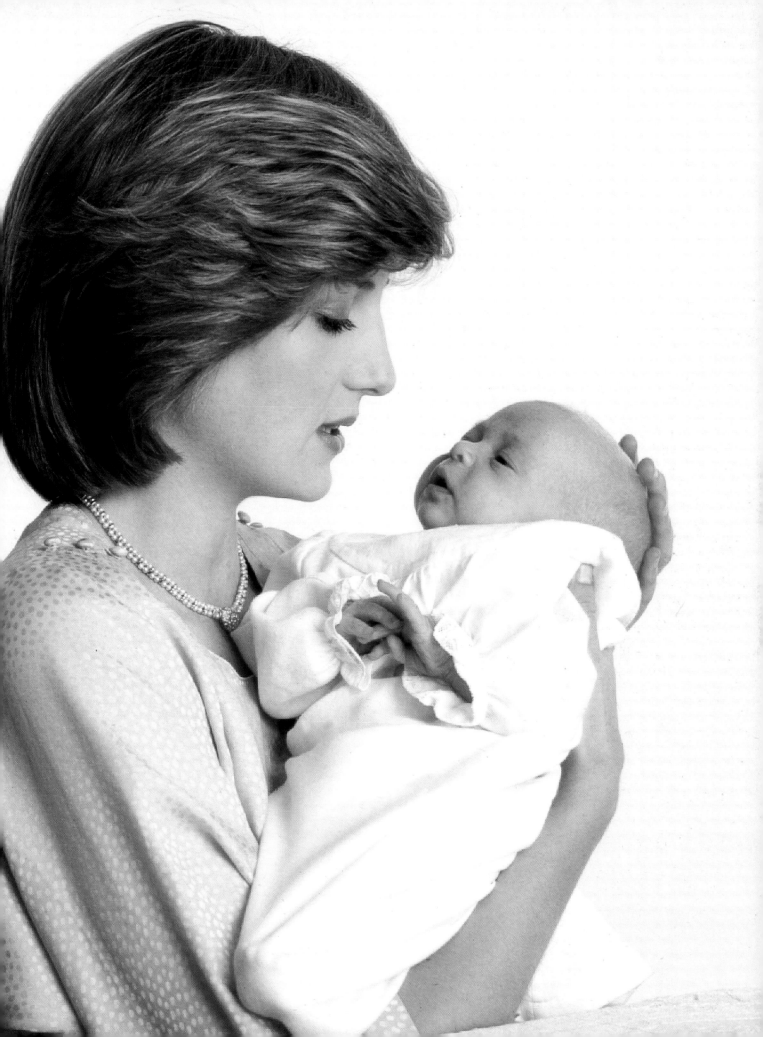

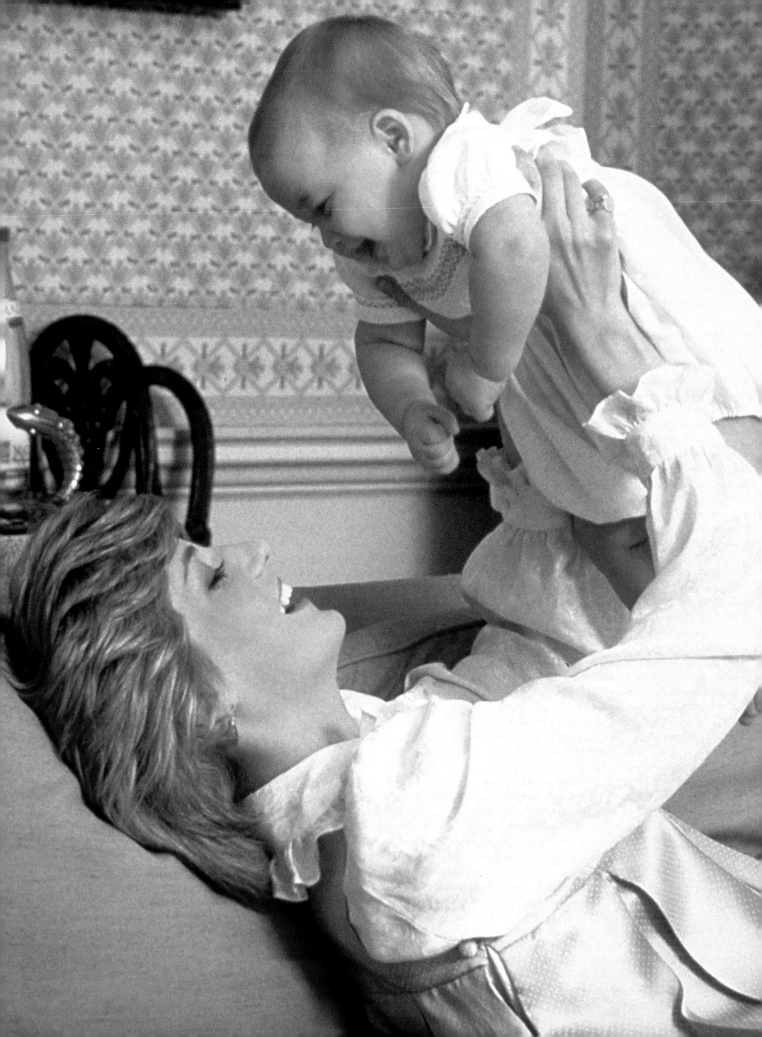

AND HARRY MAKES TWO

Opposite: In 1982, Diana's expression as she hoists her infant Wills is a very accurate reflection of the love she had for both her boys. Below, counterclockwise from top left: A Snowdon portrait made on the occasion of Harry's christening in 1984; William alone, age two, dressed for that portrait; and Charles holding an older and more dangerous Harry, who in turn grabs hold of his big brother's hair. The boys have been inseparable their entire lives.

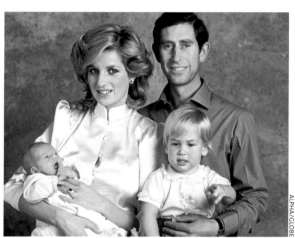

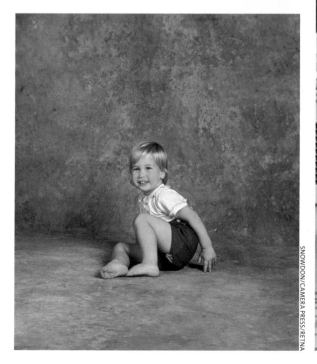

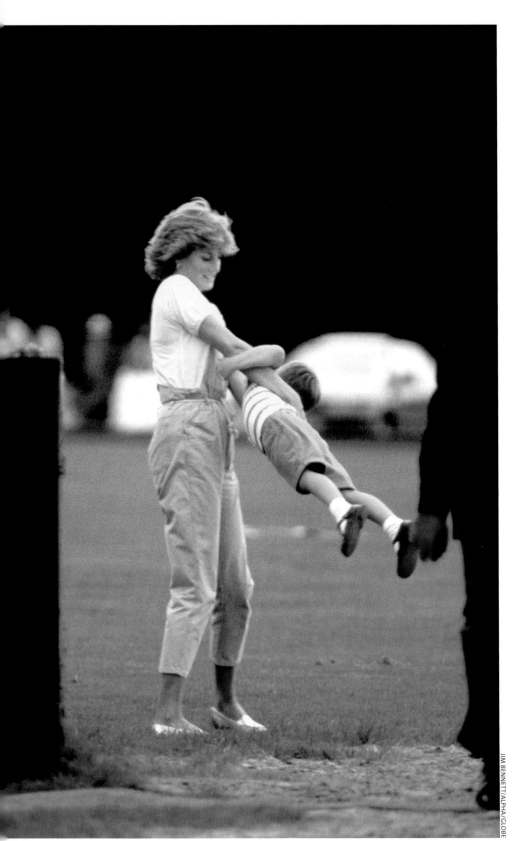

SCHOOL DAYS

Left: If, by chance, you are looking for any of the Windsors, you can often find them frolicking at polo matches, as Diana and Wills are doing in 1987. Opposite, top: Both William and Harry attended the independent Wetherby boys school in Notting Hill, west London, where in 1989 William won his heat in the Goldrush Race but placed second in the final, as did his mom in the mothers' race. Charles finished next to last among the dads. Bottom left: An upside of being a royal means vacations in high-end places, like this holiday in 1987 on the Mediterranean island of Majorca. Downside: It also means, however, that vacations are never private. Bottom right: On September 1, 1989, Harry, on his first day at Wetherby, looks up to big brother, who will set an academic pace too fast to be met.

JIM BENNETT/ALPHA/GLOBE

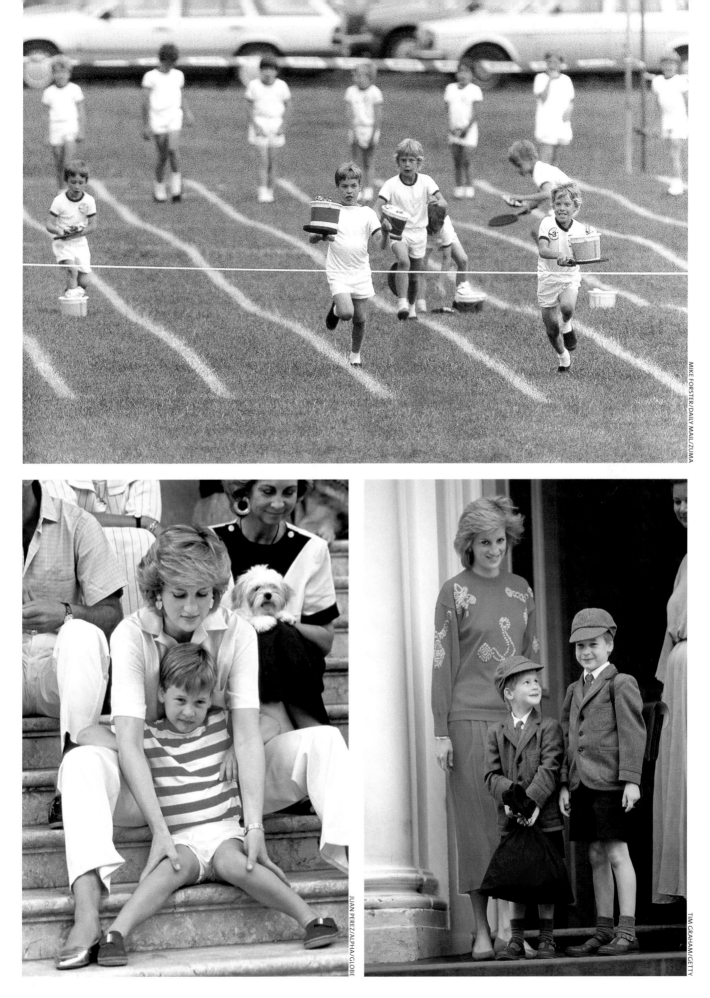

OUTINGS, OFFICIAL AND NOT

Below: In 1991, William, not yet 10, is charming while pressing the flesh at his first formal engagement as prince. Opposite, from top: Also in 1991, Harry, William and their cousin Zara Phillips; same year again, Diana and the boys visit Niagara Falls; in 1993, they enjoy a different kind of white water at Thorpe Park in England.

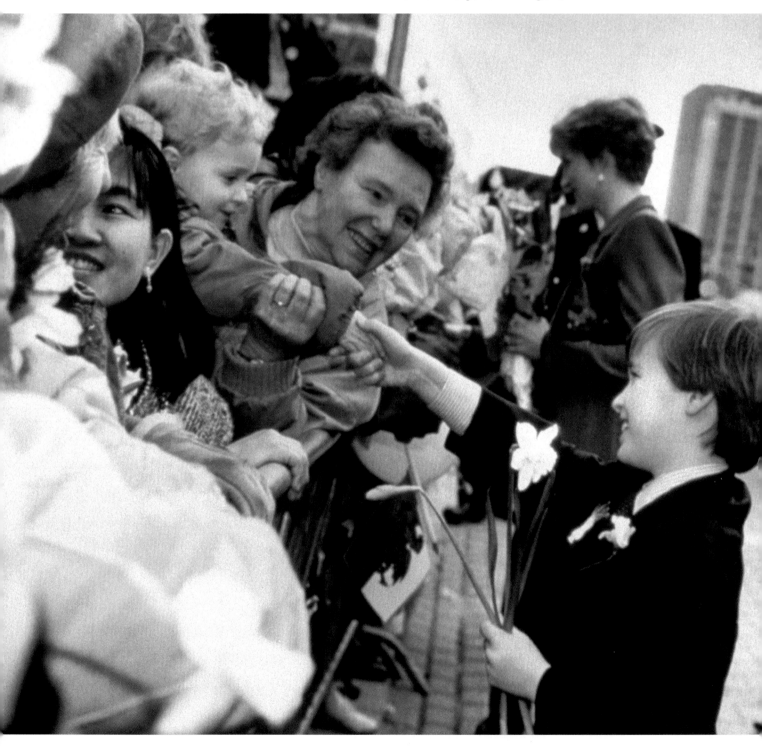

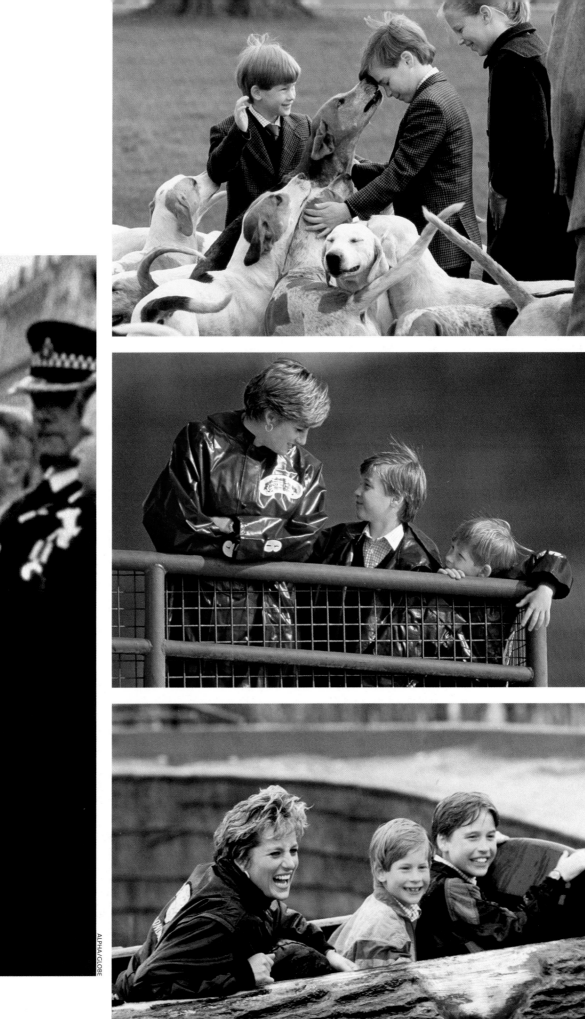

DROPPING THEIR GUARD

In November of 1994, photographer John Swannell received a call from Anna Harvey, assistant editor of British *Vogue,* who said she had a plum assignment but had to keep the subject a secret. "Finally she told me it was Princess Diana and her boys," Swannell recalled to *The Independent* in 2008. "So I had a table-tennis table set up in my studio, to stop them getting bored." While Mom was in makeup, Swannell beat William at Ping-Pong, but then Harry got the Windsors' revenge and trounced the photographer. Clearly a fun day was had by all, as these images reflect. Diana liked them so much, she chose a Swannell portrait of her and the lads as her Christmas card.

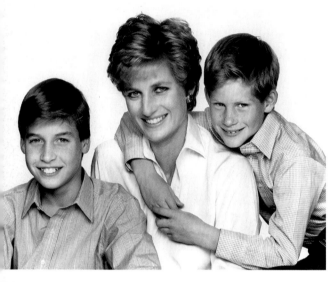

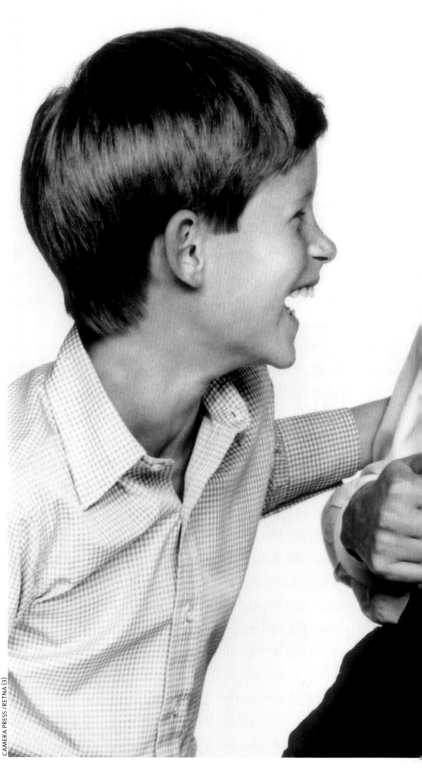

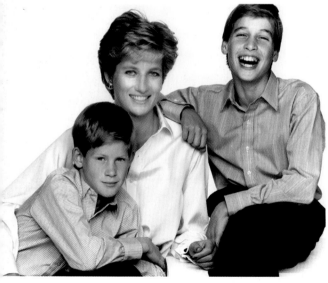

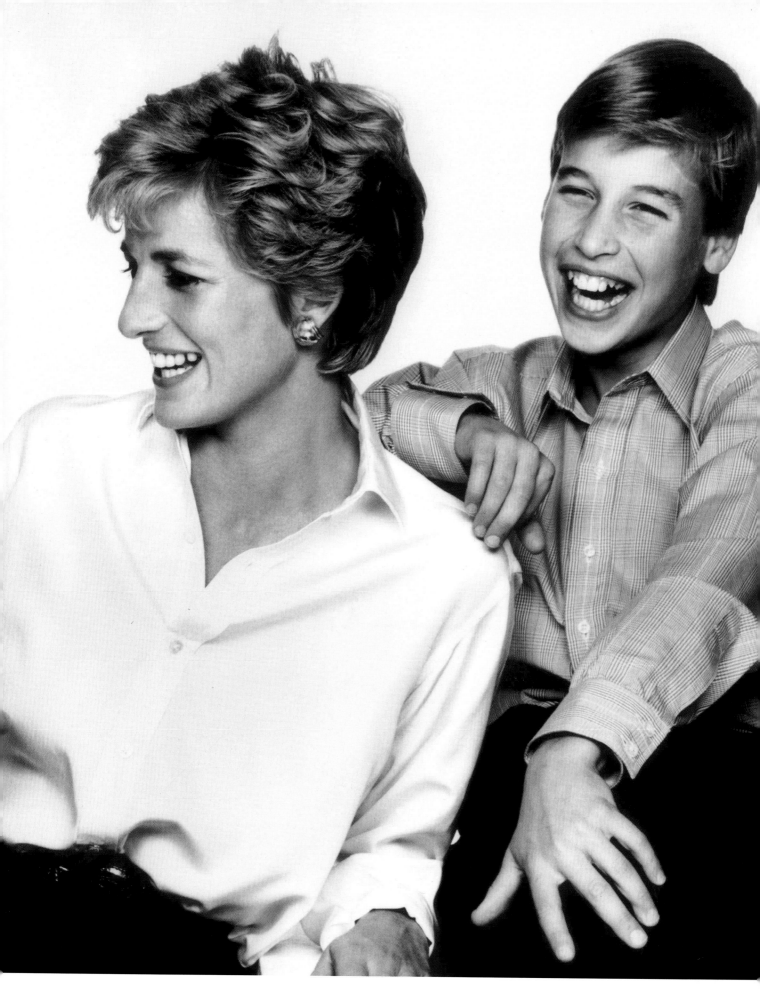

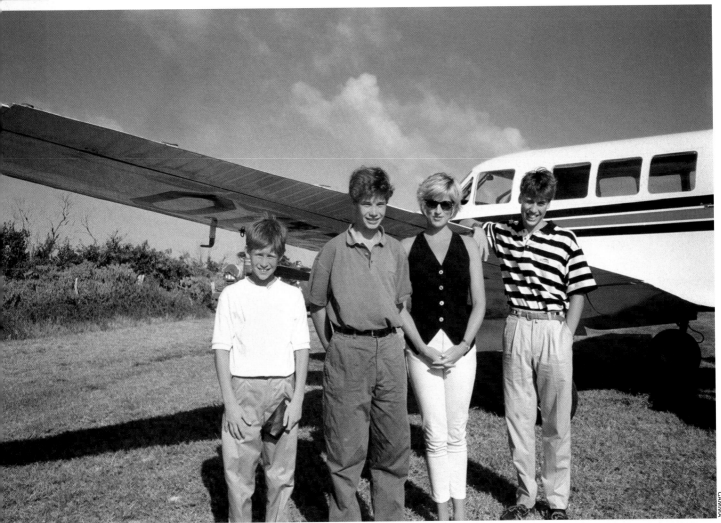

A TRAGEDY BEYOND IMAGINING

In December of 1992, Charles and Diana announced they would sep-arate, and a brutally painful period ensued for the boys as rumors of infidelity blossomed into tabloid news stories. As said earlier, there was little question that the children would continue on at Kensington Palace with Diana, and they did. They of course had no way of knowing that their family vacation in Barbuda in April of 1997 (above, with a friend of William's) would be one of the last of its kind. Opposite: After his mother has been killed in a car crash in Paris with her friend Dodi al-Fayed later that year, William dries his eyes on September 4 outside the gates of the royal castle in Balmoral, Scotland, where the floral trib-utes to Diana are piling up. Right: Two days later, at the London funeral, from top, four Windsor princes and a Spencer sibling: Queen Elizabeth's husband, Prince Philip; Prince William; Diana's brother, Charles; Prince Charles; and Prince Harry.

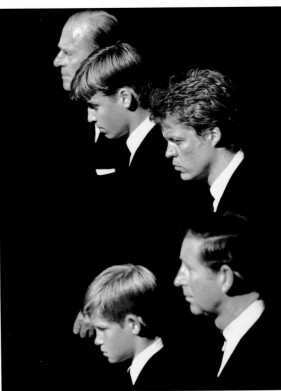

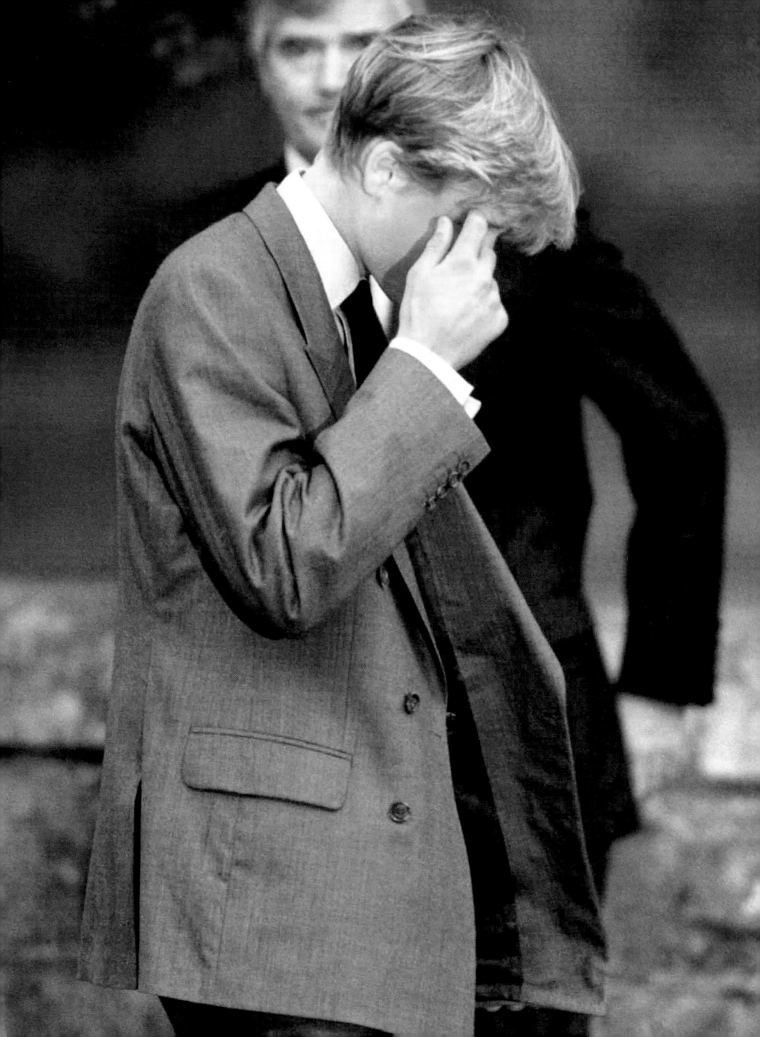

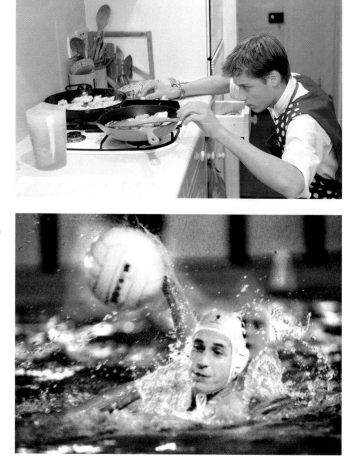

ON HIS OWN

Every June, William celebrates a birthday. Since the world audience vigorously attends his life, it is usually the case that official and unofficial photographs make their way into the newspapers and magazines. Here, in 2000, he turns 18 while a student at Eton College, and the images depict—quite truthfully—a dutiful, active young man who is reflective regarding the past and focused as well on the future. At top, he makes a paella (cooking is a course option at Eton, though the scholarly William will not need to take the "Gentleman's B" classes that, later, might appeal to the far less bookish Harry). In the middle, he competes at water polo, his favorite sport, and at bottom he's on the soccer field. Opposite: In the prefects' common room during a quiet moment.

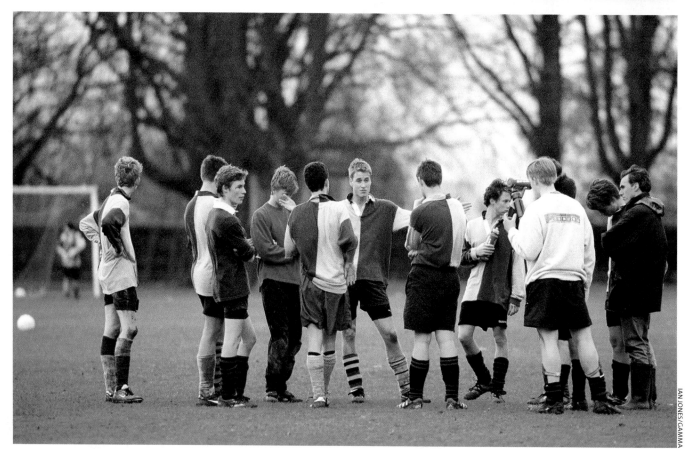

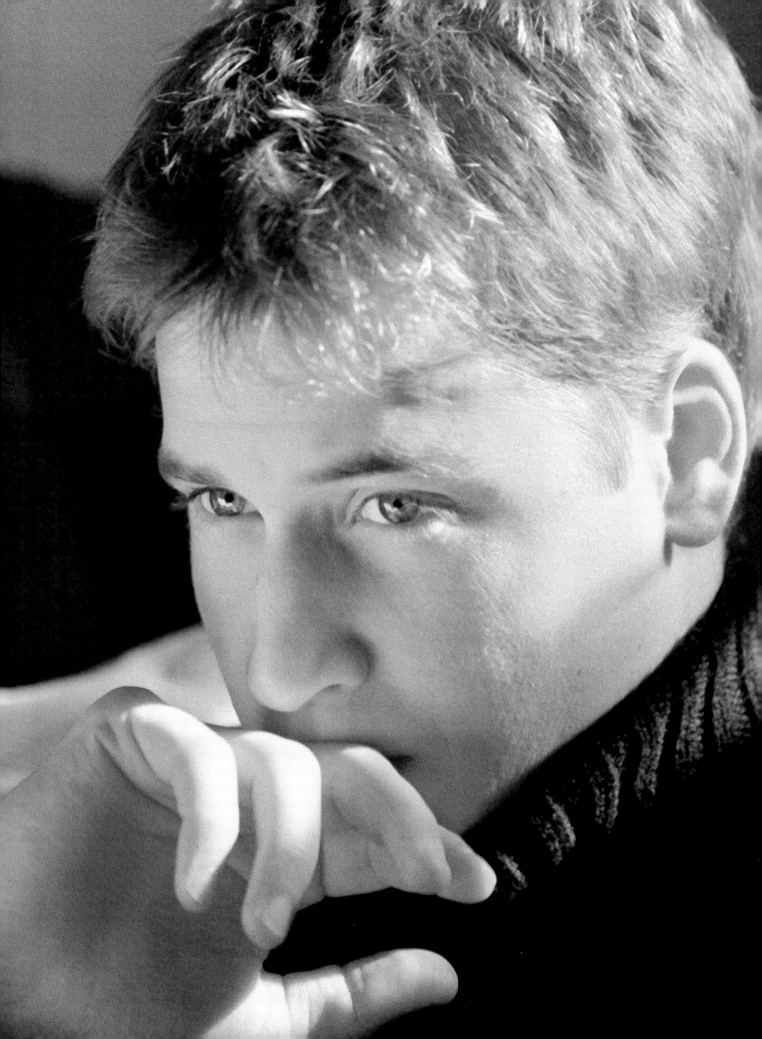

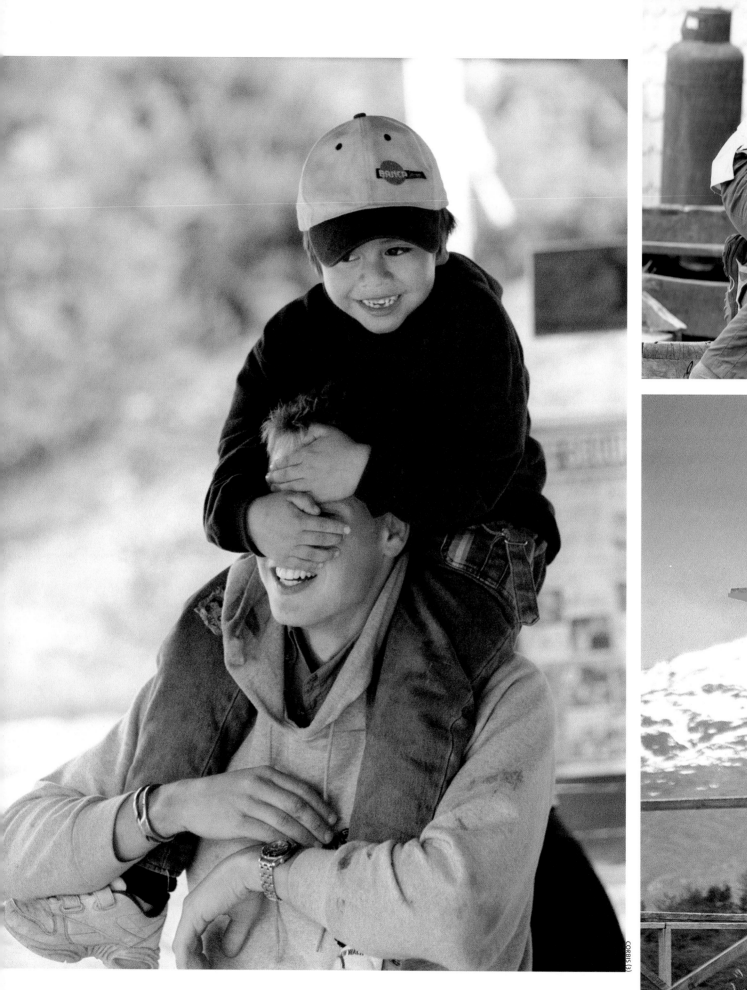

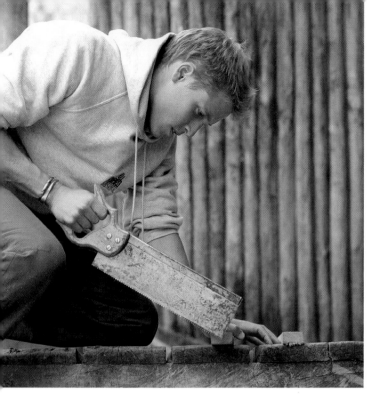

GOOD WORKS

In December of 2000, Prince William is in the village of Tortel in southern Chile doing volunteer work. Opposite: He plays with six-year-old Alejandro Heredia during a lunch break at the Tortel nursery. Left: He saws wood for the construction of a rubbish bin for the villagers. Below: He carries a beam that will be used in constructing walkways between Tortel buildings. William—along with his brother—has inherited his father's concern for the environment and his mother's compulsion to reach out and give back—as well as, it seems, her intrinsic and uncanny knack for connecting with people of both the highest and the most destitute societal strata.

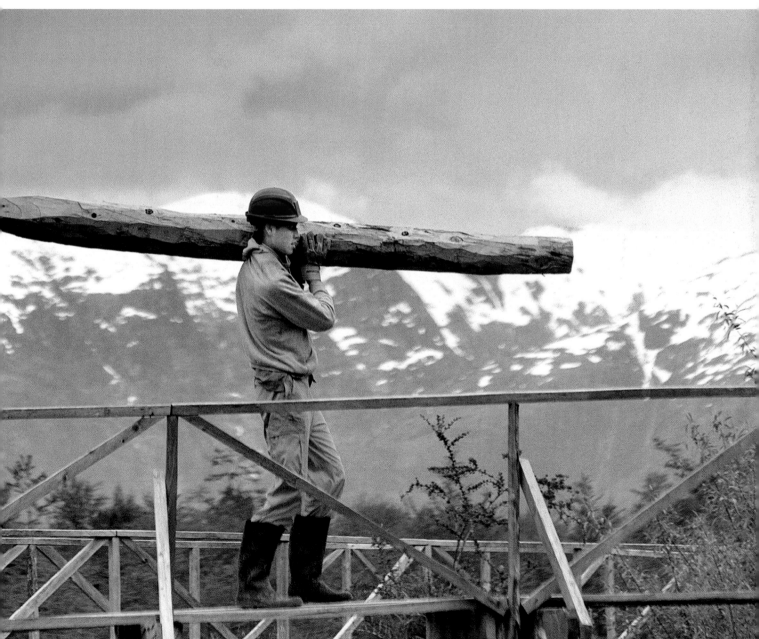

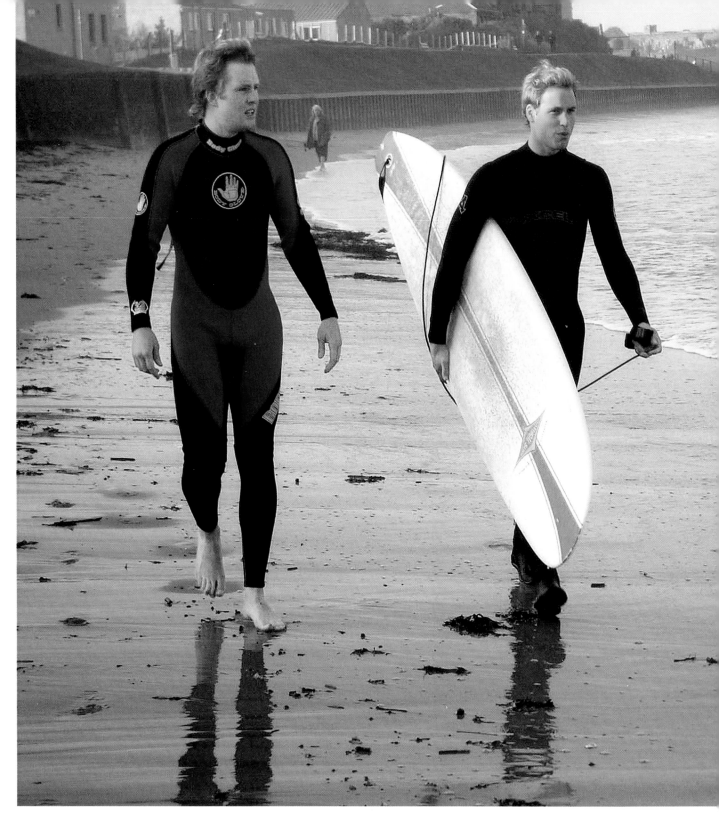

SURF'S UP (SORT OF) IN SCOTLAND

Above: The hardy final-year student at St. Andrews is flanked by his mates as they make their way home after enjoying a brisk and relatively docile North Sea in October 2004. Opposite, top: The prince shows his form with a cue stick at a St. A pub, also in 2004, and then, center, gets back to the books. His seriousness of purpose will profit him, and he will graduate from the university with stellar grades. Bottom:

On the day of the ceremony, June 23, 2005, he is accompanied by his father and stepmother, also known as Prince Charles and Camilla Parker Bowles, known, too, in England as the Prince of Wales and Duchess of Cornwall and, while here in Scotland, as the Duke and Duchess of Rothesay. Both William and his brother, Harry, have been welcoming to their father's second wife and remain close to her.

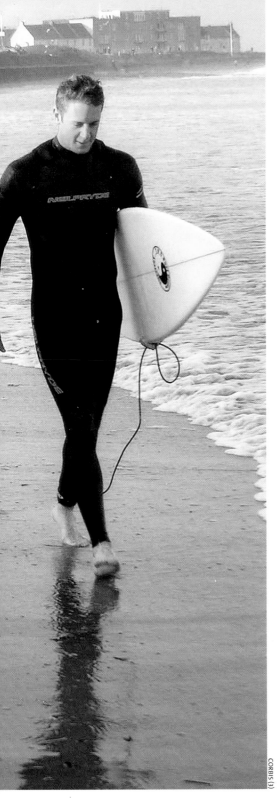

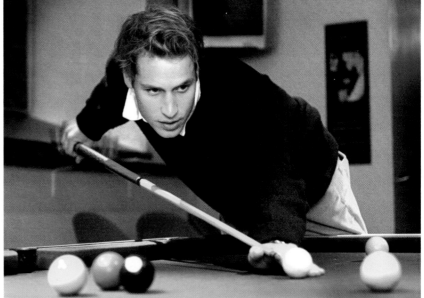

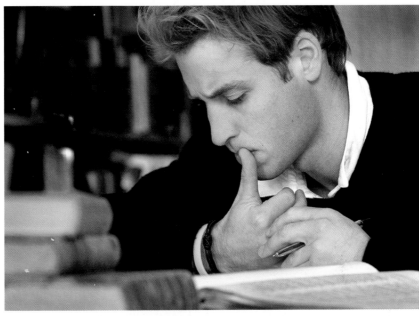

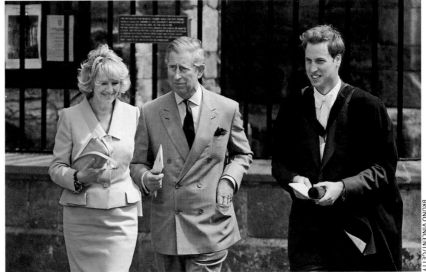

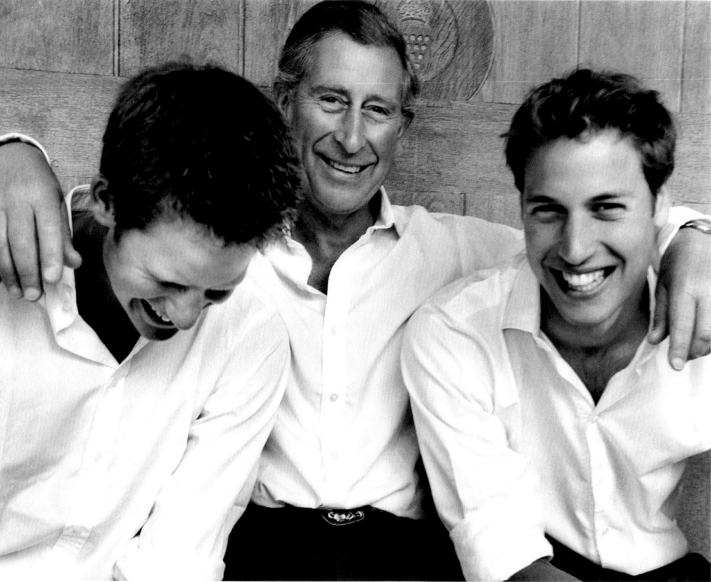

MARIO TESTINO/REUTERS

LIFE WITH FATHER

As John Swannell had a decade earlier with Diana and her sons (please see page 20), in 2004, the Peruvian fashion photographer Mario Testino well captures a familial bond (above). If Charles had often deferred to Diana as a parent, he stepped up in her absence. He was present at sporting events and when his sons began to climb the ladder in their military careers, sometimes presiding in the pinning on of wings and such. As said moments ago, when Charles wed Camilla Parker Bowles in Windsor in 2005, the boys seemed all for it, and publicly they have seemed nothing but cordial, attentive and even genuinely affectionate toward her since. Both of the pictures on these pages were taken in 2004. The Testino image was released on the occasion of Harry's 20th birthday on September 15. Opposite: Charles and William walk through a field at Duchy Home Farm, the father's organic enterprise in Gloucestershire in western England.

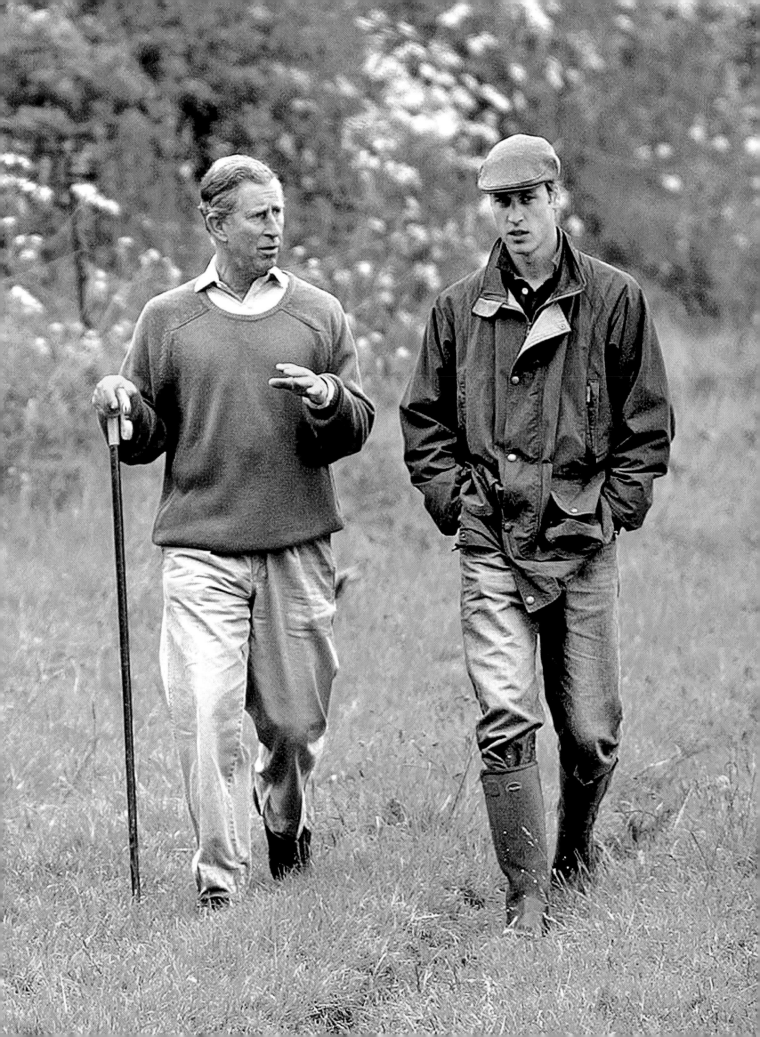

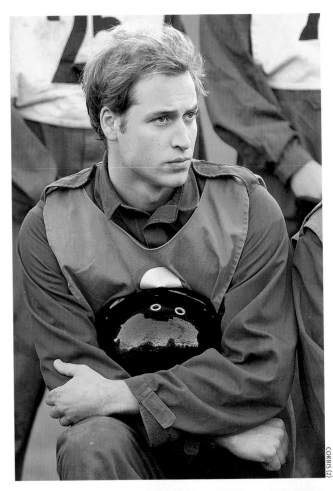

FLYBOY

After graduating from St. Andrews, William decided to pursue a military career—not unusual behavior for a royal, and a course of action that was followed by Harry as well. But once commissioned in the Armed Services in 2006, William went an extra mile and asked to participate in active service. He never did see combat, however, as it was determined that the man second in line for the throne should not be put in harm's way. William then trained with the Royal Navy and Royal Air Force and has progressed to the rank of flight lieutenant. In 2010, this helicopter search-and-rescue pilot opted for another hitch and will probably serve up to three more years. On this page, William takes part in the grueling selection process for candidates wishing to join the army as an officer with a regular commission, and is successful at the Royal Military Academy Sandhurst. Opposite: In September 2010, at the controls of his Sea King helicopter.

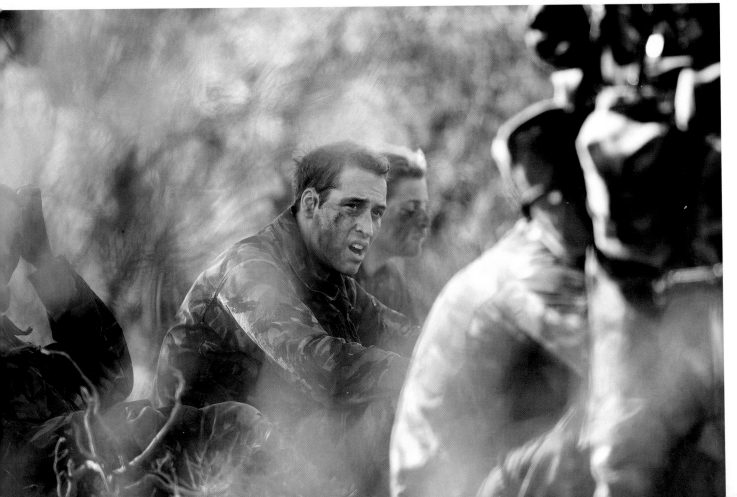

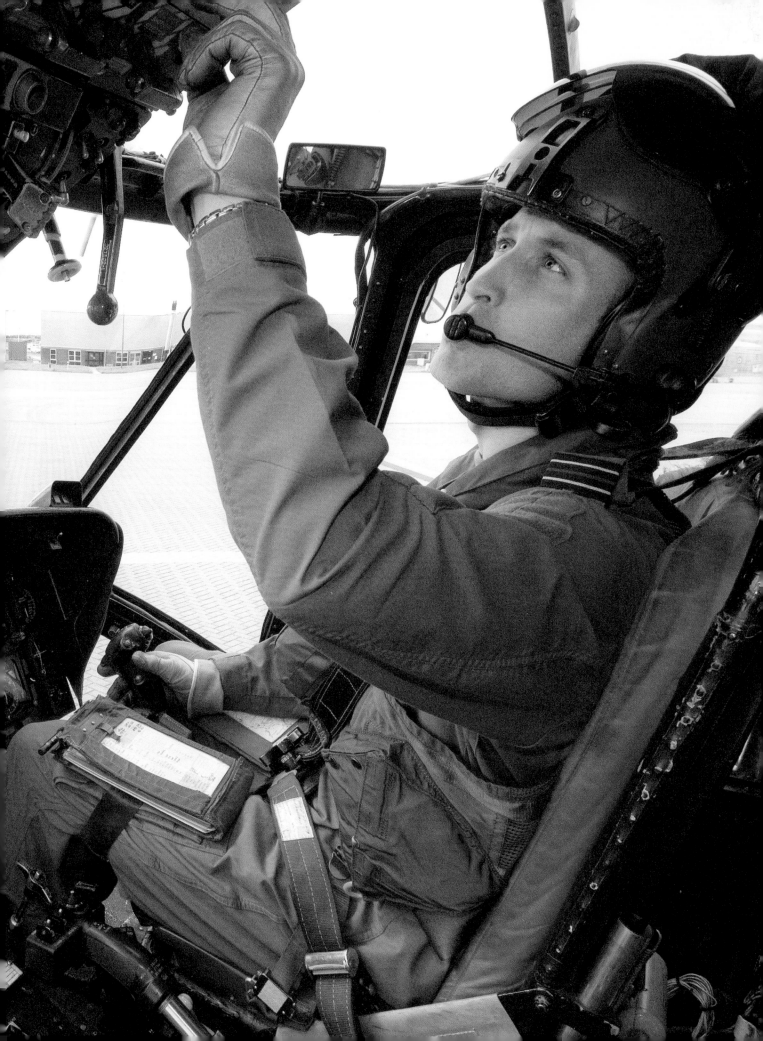

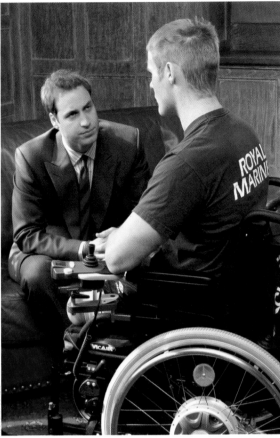

REUTERS/CORBIS

FINE YOUNG MEN

The popularity of Will and Harry has only increased in recent years as the boys have been accorded great sympathy following the death of their mother, and then admiration not only for the way they handled tragedy with grace and dignity but also for the way they've pursued their lives: in the military and in following their mother's example to do good. Below: The princes visit the Semonkong Children's Centre in Lesotho, Africa, on June 17, 2010, where they cheer orphan children. Left: Two years earlier, the brothers are at the Headley Court Defence Medical Rehabilitation Centre near Epsom in Surrey, and here William speaks with marine Mark Ormrod. Opposite: Also in 2008, a hirsute Will, along with Harry, leaves Christmas Day church services at Sandringham Estate in the eastern England county of Norfolk. The princes are always at ease in each other's company.

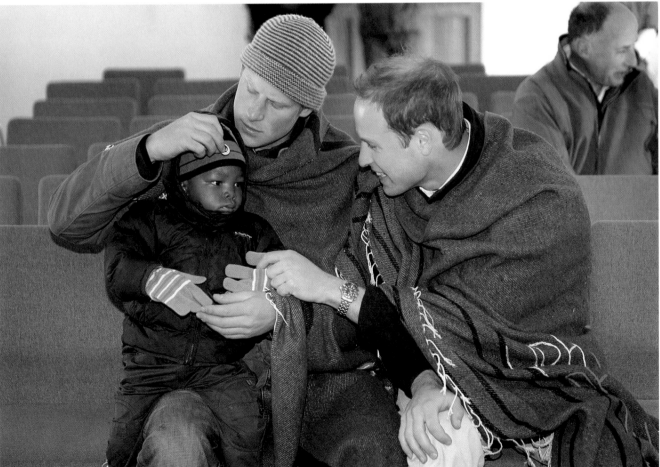

ANTHONY DEVLIN/PA/AP

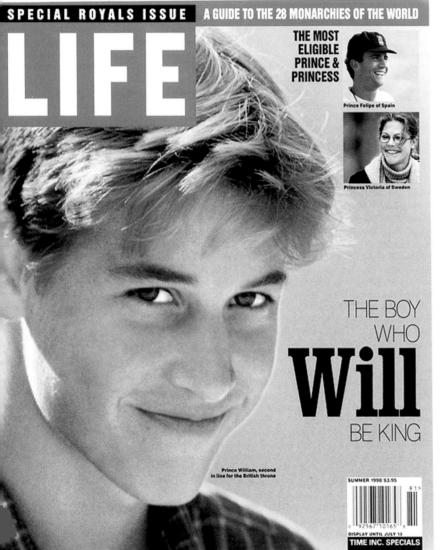

SPECIAL ROYALS ISSUE **A GUIDE TO THE 28 MONARCHIES OF THE WORLD**

LIFE

THE MOST ELIGIBLE PRINCE & PRINCESS

Prince Felipe of Spain

Princess Victoria of Sweden

THE BOY WHO **Will** BE KING

Prince William, second in line for the British throne

SUMMER 1998 $3.95

DISPLAY UNTIL JULY 13
TIME INC. SPECIALS

AWAITING HIS FATE

The special issue of LIFE (left) was published in 1998 when all the world was wondering how Will was doing in the aftermath of his mother's death. The news was that he was doing okay. Though still grieving, he seemed well poised to meet the challenges of his future—including, almost certainly, the throne. As things have eventuated since then, it has become clear that many if not most Brits wish he could be crowned tomorrow. They love Will, and they now have spent a good long time loving Kate. They don't necessarily love Charles; and polls published in the wake of the latest royal engagement, which only boosted Will's stock further, indicated that more than half of all the English hope that Will will be their next king. The son is having none of it, according to confidants, and supports his father as the sovereign-to-be. Opposite: The photograph is mildly misleading, but irresistible. William does not wait, on January 22, 2010, to assume his rightful seat and give a little wave to his subjects. He waits, rather, to address an audience in Government House in Melbourne, Australia—in the state called Victoria, after the great queen who set all this in motion. Please turn the page.

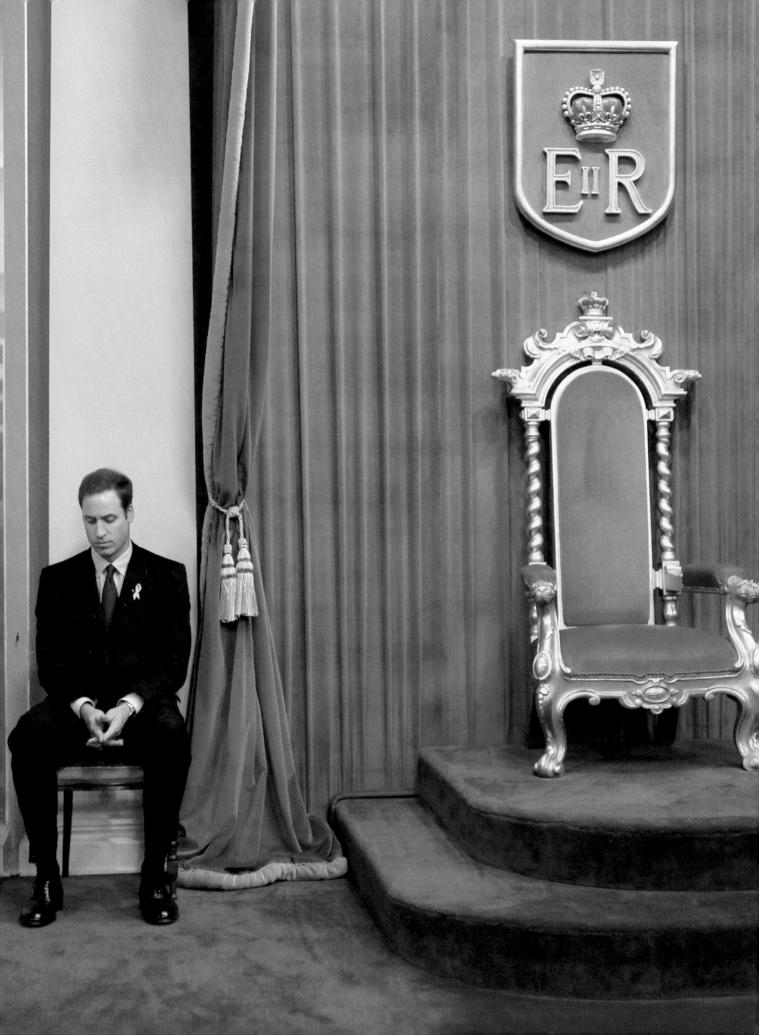

As just said, the rule of this clan started with Victoria on the throne; William Windsor, whose name couldn't sound more British, has a strongly Germanic background. Here, the great queen, still the longest serving, even with Elizabeth II's remarkable reign, poses amidst family in Coburg, Germany, in 1894.

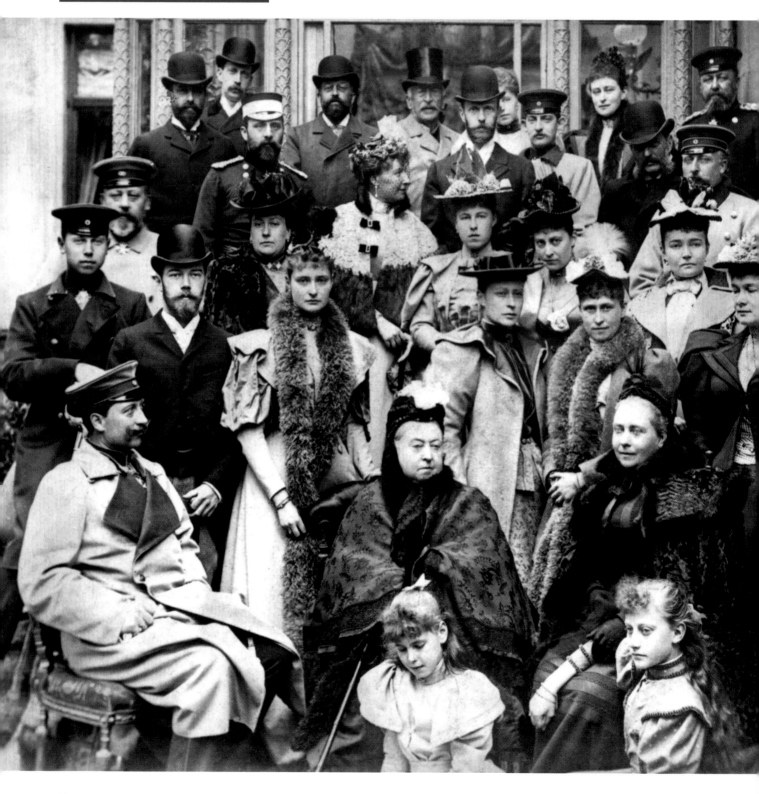

II MEET THE WINDSORS

I'S FAIR TO SAY THAT MOST MEMBERS OF THE ARISTOCRATIC, THOROUGHLY Continental, enigmatic, problematic, often arrogant and vigorously royal family that descends from the legendary Queen Victoria, might never have supposed that, in the new millennium, their heritage and legacy would rest upon the shoulders of a lad called, commonly, Wills. Most probably, King Wills, one day. But those are the facts, and it should quickly be said: Wills's course in life is a shining star when set against the examples of some of his forebears—philanderers, abdicators and just-plain-twits among them.

Certainly there have been heroes. King George VI, who reigned during World War II, stands out; and beloved in their time have been several women, including George's wife, Elizabeth, the best known of the Queen Mums; Diana, Princess of Wales; and the formidable queens Victoria and Elizabeth II, who reigns to this day. But the Windsors have enjoyed such an erratic run on the throne that, on more than one occasion, they have caused even the most loyal of their subjects to question whether the monarchy, which has been largely for show and without real power throughout their long tenure, is worth the bother and, particularly, the expense.

The term *House of Windsor* does not reach all the way back to Victoria—it was adopted for political purposes during World War I—and in fact, Victoria, the granddaughter of King George III and niece of King William IV, who immediately preceded her as British sovereign, was the last ruler of the House of Hanover. She was of mostly German descent: Her father was Prince Edward, Duke of Kent and Strathearn, and her mother was Princess Victoria of Saxe-Coburg-Saalfeld. The young Queen Victoria married Prince Albert of Saxe-Coburg and Gotha, son of the German Duke Ernst I, and that only made matters more Germanic. Which, after she ascended to the throne in 1837 to begin a 63-year reign (longest to date of any British monarch), was all well and good . . .

For a while.

At the christening of Prince Harry in 1984, the
modern-day Windsors are: Charles and Diana
and the queen in the front, middle; the Queen
Mum in the front row, second from left; Prince
Philip, the queen's husband, in the center of
the second row (with Prince Andrew on his
right hand and Diana's father, John Spencer, on
his left); William, our hero, standing in front—
and a host of other happy friends and family.

Victoria wanted her son, when and if he ever did get to succeed her, to rule as a representative of the House of Wettin, a thousand-year-old German family of which Saxe-Coburg was a branch. This, she felt, would properly celebrate England and Germany's shared Saxon heritage. Edward VII did indeed reign as a member of Saxe-Coburg and Gotha, as did his son George V. But then war swept the Continent, and the British people were feeling none too chipper about things Germanic. On July 17, 1917, George V made a masterful PR move, as kings are empowered to do, and issued this decree: "Now, therefore, We out of Our Royal Will and Authority, do hereby declare and announce that from the date of this Our Royal Proclamation Our House and Family shall be styled and known as the House and Family of Windsor, and that all the descendants in the male line of Our said Grandmother Queen Victoria who are subjects of these Realms, other than female descendants who may marry or may have married, shall bear the said Name of Windsor." And so it has been, ever since.

Victoria's Victorian Age, Edward's Edwardian Era (1901–1910) and George's relatively long and sometimes rocky reign, from 1910 to 1936, gave way to the short, notorious tenure of his and Queen Mary's eldest and instinctively rebellious son, who became the Windsor king Edward VIII. Even before his ascension to the throne, Edward was involved with one Wallis Warfield Simpson, an American divorcée, and when he said that his love for her was deeper than his dedication to the monarchy, he was forced by scandal to abdicate, having served less than a year. He was succeeded by his brother, who became King George VI, and this turned out to be a very good thing. George and his wife, the former Elizabeth Bowes-Lyon, who would become world famous as the sweet-smiling, hat-wearing old lady known as the Queen Mum, were inspirational figures during the Second World War, touring the bombed-out East End during the Blitz, saying all the right things. George VI died young (at age 56) in 1952, the victim of far too much smoking. His elder daughter, Elizabeth, would succeed him. By then, Great Britain had emerged from the chaos. And so had the monarchy—or so the monarchists hoped.

Elizabeth II remains on the throne today, having experienced greater glories and deeper disappointments—even horrors—than she could ever have imagined. The travails of her son Charles, who is first in line of succession to the throne, would have been enough to sink any less formidable woman.

OTTO HERSCHAN/GETTY

QUEENS AND FUTURE KINGS

We don't want to make too much of this—well, perhaps we do—but the contrast between the Windsors and the Middletons, as proved by narrative facts and also by the pictures, couldn't be greater. The former is an ancient clan reaching back through centuries to folks who once ruled an empire upon which, as they say, the sun never set. The latter is an engaging end-of-the-millennium family that does not foist funny clothes on the kids. Above: Victoria with her grandchildren in a pony and trap at Osborne House on the Isle of Wight, with personal attendant John Brown, who would serve the queen loyally for 34 years until his death at Windsor Castle in 1883. Right: George, Duke of York (right), and Albert, Duke of Clarence, in traditional Scottish garb in 1875. George would become King George V, seen (opposite, top) riding in Windsor Great Park with his own sons, one of whom would become Edward VIII and would soon thereafter abdicate in 1936, another of whom would then become George VI and would be reintroduced to movie audiences worldwide in the 2010 film *The King's Speech.* Opposite, bottom: The future Edward VIII (right) and his brother, again, saluting Britannia circa the turn of the 20th century.

PRINT COLLECTOR/HIP/IMAGE WORKS

HULTON-DEUTSCH/CORBIS

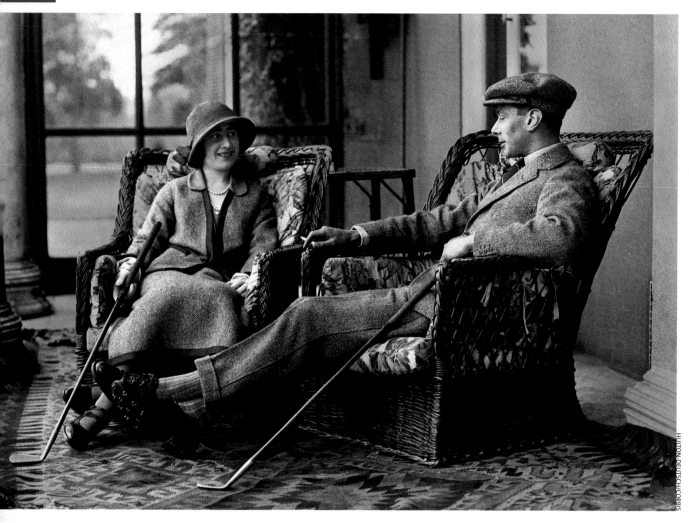

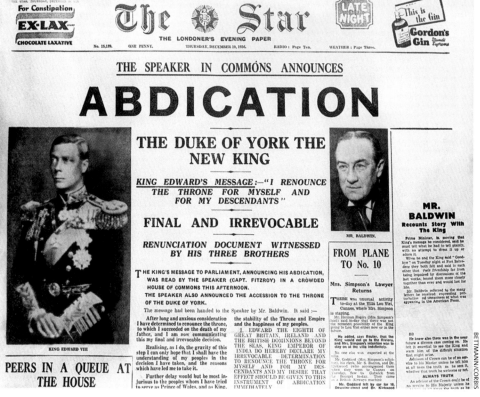

THE WOMAN WHO WOULD BE QUEEN

Opposite, top: Albert and Elizabeth, the Duke and Duchess of York, during their veddy British honeymoon in 1923. She is the former Elizabeth Bowes-Lyon, the indictment against whom is that, as a young woman, she aspired to be the queen of England one day, and that she ambitiously set her sights on Edward, Prince of Wales, only to be spurned by him, whereupon she settled for his kid brother, Albert. If so, then fate smiled broadly on Elizabeth when Wallis Simpson entered the picture and King Edward VIII exited the frame by abdicating (bottom) and handing the crown to Albert, who as we know became George VI. It should be said in her defense: If Bowes-Lyon wanted to be queen—well, what girl doesn't? Once she *was* queen, she and her husband were as good a king and queen as Merrie Olde England has ever been blessed with, inspiring their people through the dark days of the Blitz and World War II. The woman who would become known in her seniority as the Queen Mother is seen above in the gardens of Buckingham Palace in a 1939 Cecil Beaton portrait.

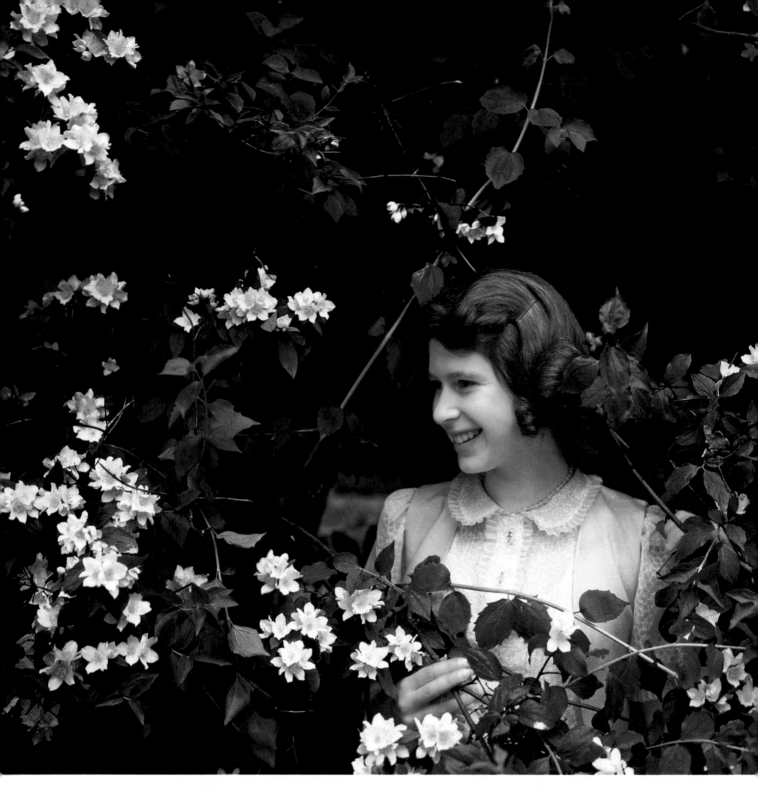

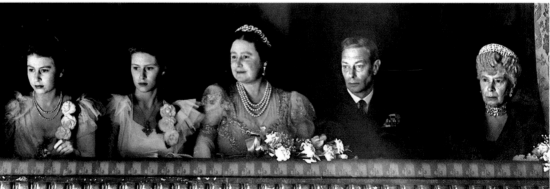

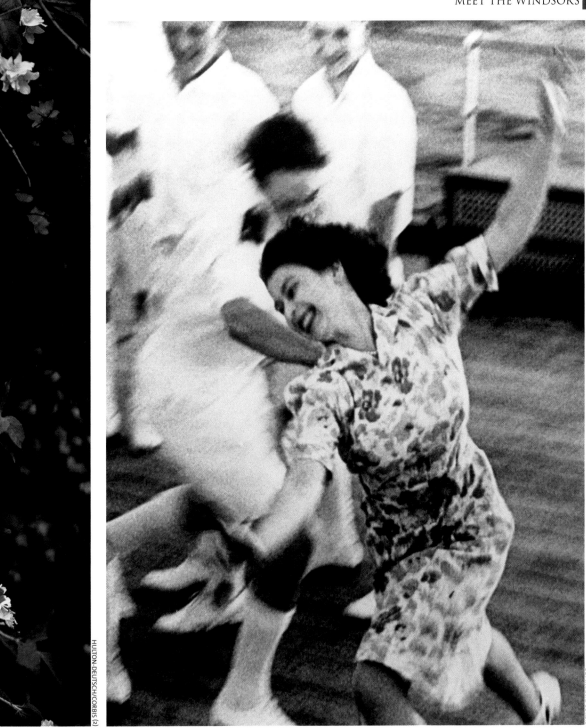

HULTON-DEUTSCH/CORBIS (2)

BETTMANN/CORBIS

UNSEEN SIDES OF ELIZABETH II

The modern audience, with an opinion informed by her public responses to travails and scandals, and perhaps by the movie *The Queen*, sees Elizabeth, who has been on the throne for nearly 60 years, as constantly dour and unsmiling—as on the opposite page, bottom, upon the reopening of the Royal Opera House in February 1946. (Fanning out beside her are her younger sister, Princess Margaret; her mother, Queen Elizabeth; her father, King George VI; and her paternal grandmother, Queen Mary.) But Elizabeth was a lovely and vivacious girl. Above, left: She poses in 1941 at age 15 amidst the syringa bushes at Windsor. (During the war, Elizabeth and Margaret are often at this castle, well out of town for safety's sake, while their parents make a show of being at Buckingham Palace, which has been bombed, as often as possible.) Above: While on board the HMS *Vanguard* in February 1947, Elizabeth plays tag with midshipmen.

KEYSTONE/ZUMA

WHAT TO THINK ABOUT CHARLES?

He was such a cute boy when entering palatial realms more than a half-century ago (above). That was back in the day when everyone looked forward to him being king, as they do now with his own son William. But just as the reputation of Philip, Elizabeth II's husband, has suffered over the years and his popularity has diminished, the adult Charles, Prince of Wales, has seen the affection of his subjects wane. Too much has come out about whether or not he ever really loved Diana and whether his affair with Camilla Parker Bowles was ongoing during the whole of his first marriage. The Charles-Camilla tape recordings: *Goodness!* Worse even than Diana and James Gilbey's so-called Squidgygate tapes. But through it all, as they must, the Windsors keep up appearances. Right: Charles kisses the hand of his mother, the queen, after the Cartier International Day polo match in July 1985. Opposite: On June 2, 2003, at a Clarence House dinner to mark the 50th anniversary of Elizabeth's coronation, the queen poses with her son and elder grandson, one of whom will most probably succeed her on the throne.

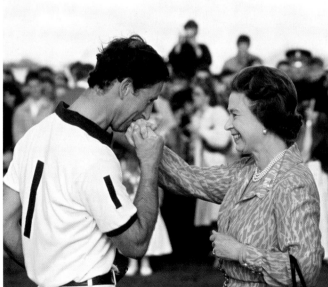

HULTON-DEUTSCH/CORBIS

ANWAR HUSSEIN/GETTY

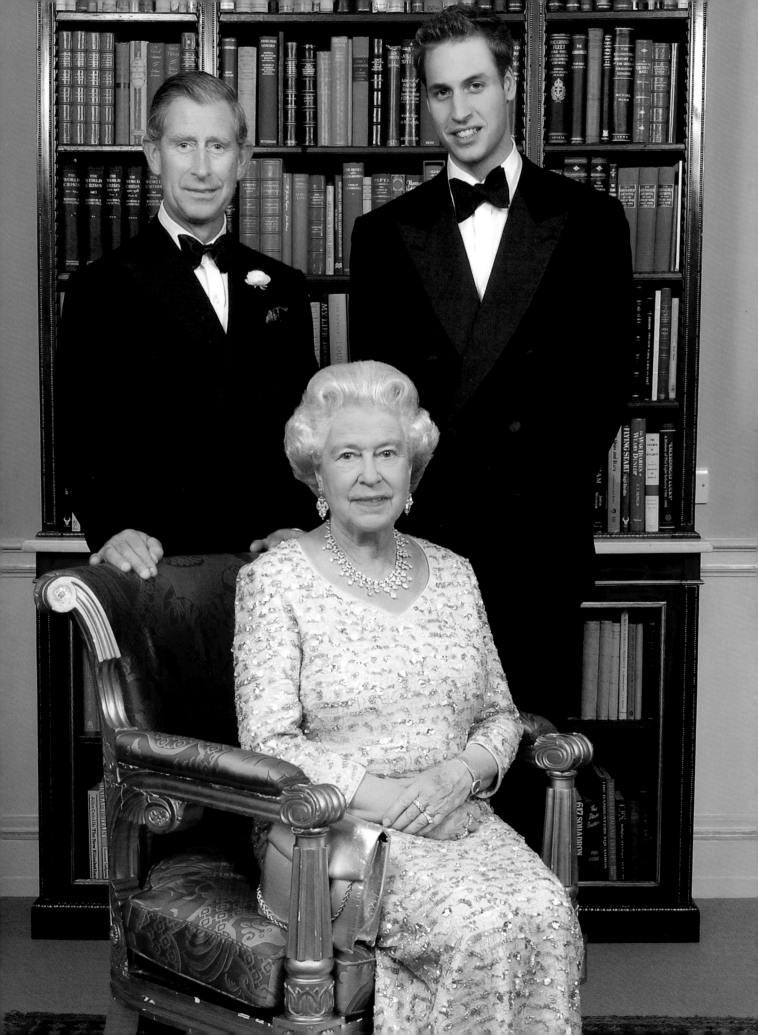

III

HIS PRINCESS

THE KATE MIDDLETON STORY IS HARDLY ELIZA DOOLITTLE'S. SHE IS NOT SOME guttersnipe who has been molded by 'enry 'iggins so that she might circulate amidst and even conquer London's aristocracy. But hers is a story that is singular in the annals of the British monarchy. She is without doubt or qualification (and somewhat proudly) "a commoner." She's a very pretty, well-bred, intelligent, well-educated, stylish . . . *commoner*. Those of her station are simply not put in a position to be half of the Commonwealth's ruling couple. England did once offer the crown to the fiercely powerful Oliver Cromwell, so it seems technically possible that a commoner could be king. The eternal tradition, however, is for those in line of succession to choose their spouses from the titled class.

The times, they have a-changed.

We will learn more about the Middleton family, the patriarch and matriarch of which are self-made millionaires, in the chapter immediately following. But for now: Kate.

She is 29 years old, born Catherine Elizabeth Middleton on January 9, 1982, the first child of Michael and Carole, who live today in a quaint English village with a central-casting name: Bucklebury. Kate's parents had already made good money as entrepreneurs by the time their daughter entered girlhood, and she was raised largely in comfort. While her future betrothed, William, suffered—and in full public view—the youthful torments of watching his mother and father grow apart and then divorce sensationally, Kate was brought up, along with her younger brother and sister, in a loving environment. During a television interview, she said of family: "It's very important to me. We see a lot of each other. They're very, very dear to me."

She attended private schools, was a good student and showed her abilities in all sports early on. The most often reprinted photographs from her early years (the best of which are reprinted yet again in our book) show her as a member of this athletic squad or that one—tennis (she was captain of her high school team), track, field hockey. Later, she would

Cute as a button and destined to be lovely as a lark, Kate smiles at St. Andrews School—from which she is headed (though she certainly can't know it yet) for the august University of St. Andrews in Scotland. There, she will meet her guy—and her fate.

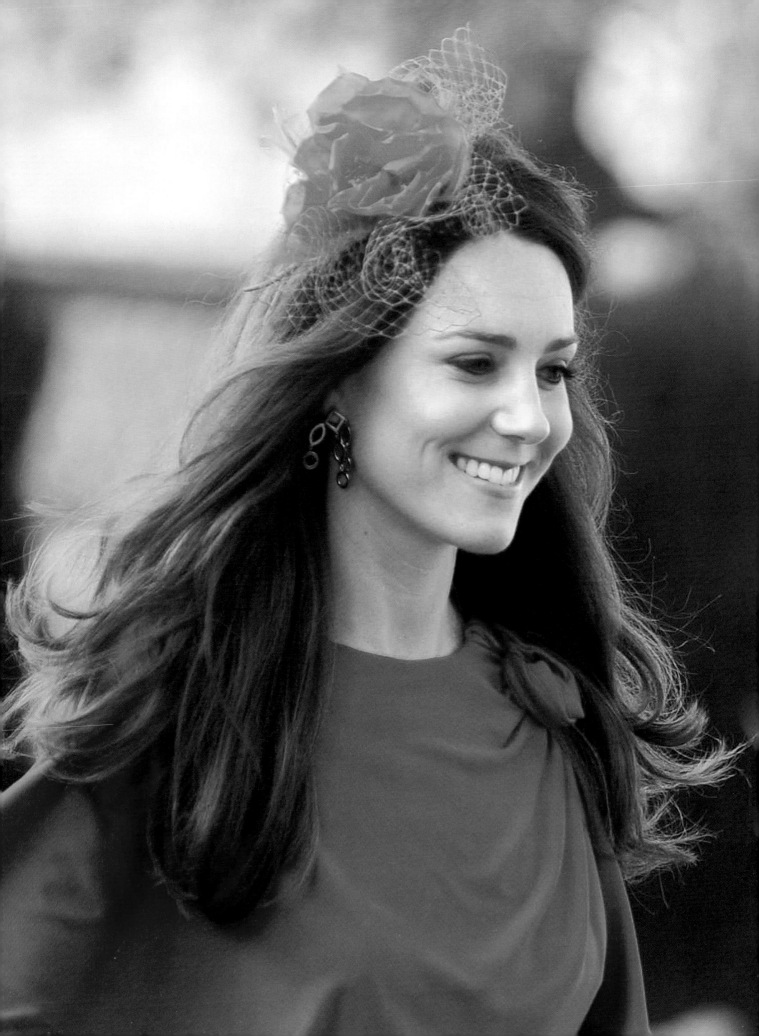

crew, and she has long been a fine skier. She was admitted to the University of St. Andrews, where she majored in art history—as did a young man named William, Prince of Wales.

Kate was always lovely, effervescent and popular in her circle, but self-assurance came only with time. "She wasn't really confident," a former classmate told *People* magazine in 2010. "The poor girl, we felt sorry for her."

Another friend said of her arrival at St. Andrews: "She was among a set of girls who were quite traditional, where if they were going to have a man, it had to be a really romantic, sentimental thing." Yes, but it is an interesting historical footnote that one of the first times William spotted her—certainly one of the first times he really noticed her—was when she was modeling racy lingerie in a student charity fashion show, a catwalk appearance that yielded another set of oft-republished photos that, certainly, the Palace would today withdraw from global circulation if it had the means.

What all of this added up to was: a normal (if better looking and somewhat smarter), vivacious, fun-loving, spirited young woman. "We have a great, fun time together," William said at the 2010 press conference announcing the engagement. He added, "She has a really naughty sense of humor."

The public has had little difficulty believing in the humanness of Kate Middleton, and seemed to be openly rooting for their betrothal during a decade of courtship. Meantime, she grew ever stronger in her public persona, becoming, as Diana had, a style icon and trendsetter—but always with a difference. Her fans knew she had been one of them. When rumors circulated that the queen was less than in love with the idea of a union of Will and Kate, and that perhaps this was because the young woman hadn't curtsied quite the right way or had deigned to ask directions to the Buckingham Palace loo, Kate only became more attractive to the less-than-royal classes.

Part of what makes Kate Middleton and this particular prince-and-princess story fascinating and romantic is just that: the Cinderella angle. Any number of metaphorical mean stepsisters with lots of jewelry and many titles now gnash their teeth by the wayside, as the commoner, who arrived as if by pumpkin coach, enters the Palace. For good.

In April of 2010, Kate attends one of the several marriages of her and Will's friends that have been celebrated in the interim of their long courtship. This one is that of Emilia d'Erlanger and David Jardine-Paterson in Tiverton.

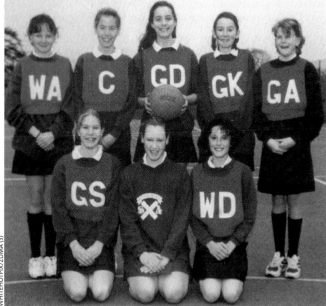

WHITEHOTPIX/ZUMA (3)

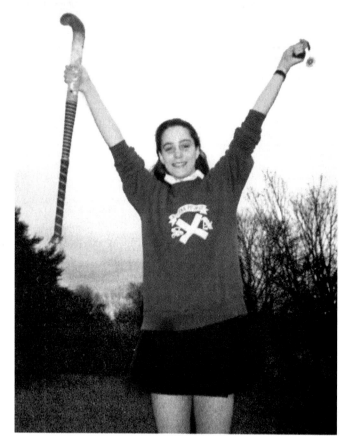

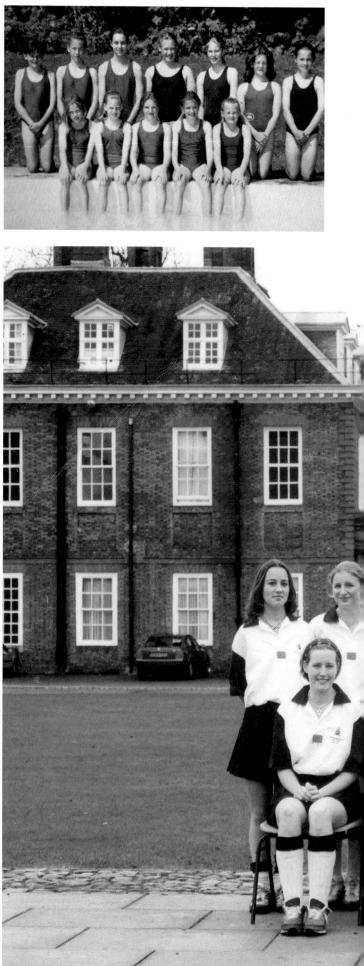

THE SUN/NI SYNDICATION

NOTHING IF NOT SPORTING

That headline does not refer to her long wait for a ring, but rather to Kate's athletic prowess—a central part of her being that was on exhibit early. At St. Andrews School in Pangbourne, Berkshire, a coed prep school she began attending at age eight in 1989, the yearbook from June 1995, her final year, talks of her playing on the netball, rounders and field hockey teams, as well as winning her age-group cup for outstanding sporting achievement. Opposite, top left: The netballer, in the center of the back row. Bottom: The field hockey player. Top right: With her youth swim team, back row, third from left. She went from St. Andrews School to Marlborough College in Wiltshire, where she again competed in field hockey (below, standing, fourth from left) and other athletics. Left: Hoofing it during School Sports Day.

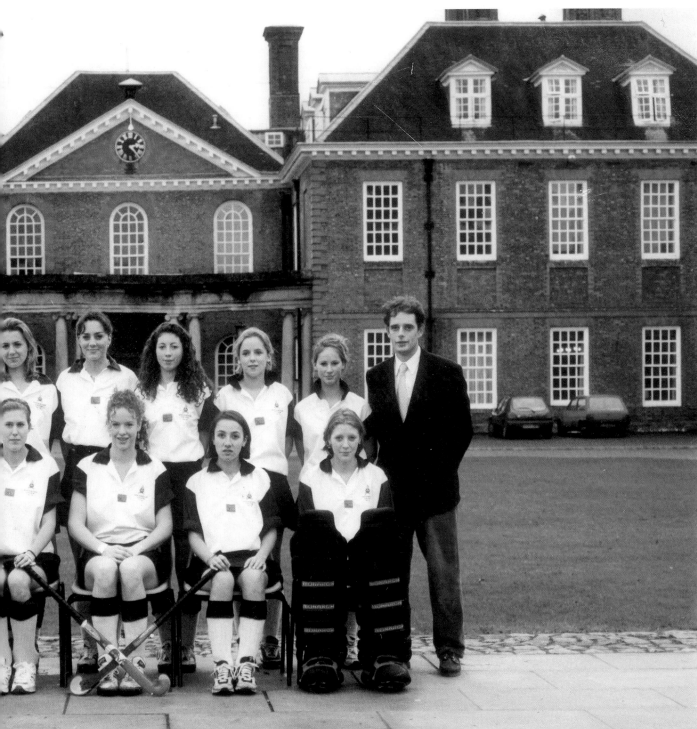

SOLO/ZUMA

GOOD MEMORIES

Opposite, top left: Kate glances over her shoulder as her mother, Carole (right), supervises a birthday party—only a few years after the Middletons started their lucrative party goods business. Top right: Kate (far left) poses next to her sister, Pippa, and two pals. Center: Kate in a pantomime portraying (right) the medieval mayor of London Dick Whittington. Bottom: We said in our introduction to this chapter that Kate was not Eliza Doolittle, the protagonist of *Pygmalion* and *My Fair Lady*—but here she *is*, in fact, Eliza Doolittle, in a school production. Below: Circa 2000, with Marlborough College pal Gemma Williamson. Kate "would have time for everyone," Williamson told *People* magazine in 2010.

DIANA REDUX

Back in the early 1980s when Diana moved from her Sloane Rangers look to a high, if seemingly effortless, fashion sense, courtiers and the general public couldn't have been more thrilled. Kate always looked good in whatever she wore, but once in the limelight she tried a few things (even those stick-on hats!)—and similarly drew applause. In this sampling, below, left and right: A sheer back and plunging front on the streets of London in September 2007. Right, top and bottom: Two hats from 2006, an extravagant display worn to the wedding of Laura Parker Bowles and Harry Lopes in May, and a furry number donned for the Cheltenham horse racing festival in chilly March. Opposite: Elegance personified. In the photograph at right, Kate is accompanying William to the London wedding of Captain Nicholas Van Cutsem and Alice Hadden-Paton on August 14, 2009. By now, rumors are rampant and the public's patience is growing thin. The prince is teased at the event, "You'll be next!"—but he walks on. Still, sources close to the couple are whispering that a "secret pact" has been made to wed sometime in 2011.

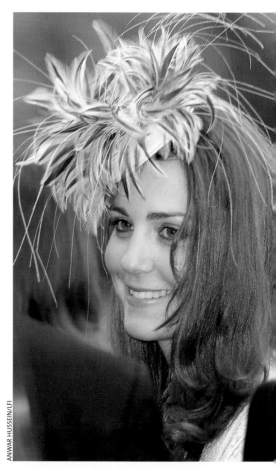

ANWAR HUSSEIN/LFI

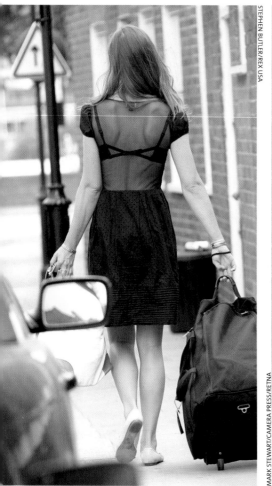

STEPHEN BUTLER/REX USA

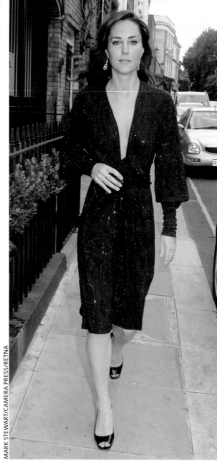

MARK STEWART/CAMERA PRESS/RETNA

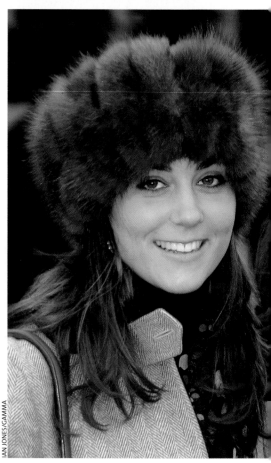

IAN JONES/GAMMA

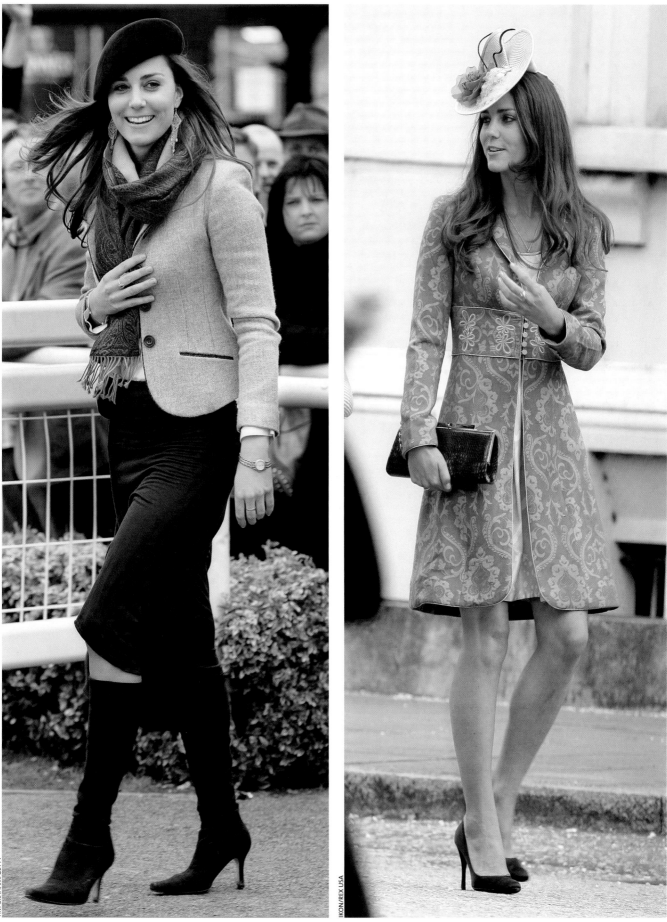

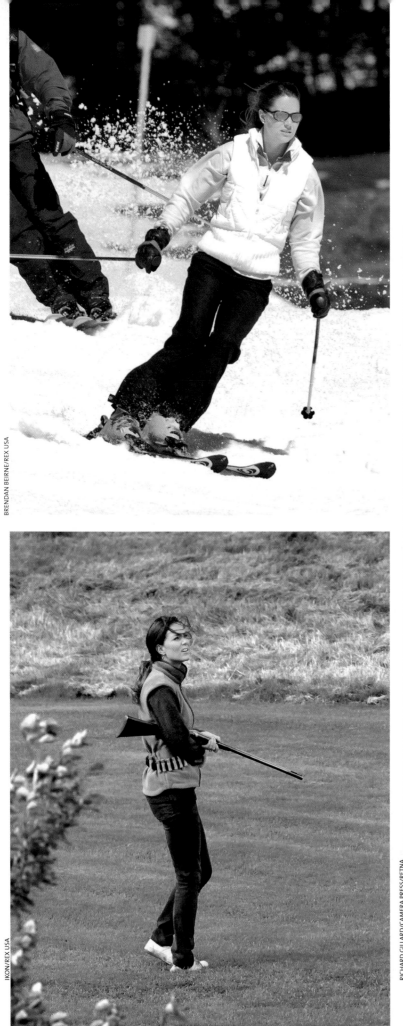

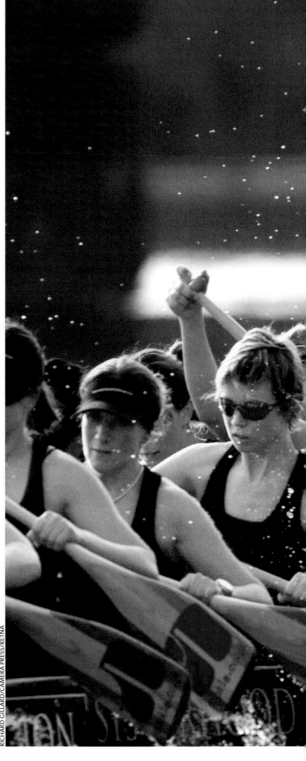

GOOD FORM

Royals are always pictured skiing at the deluxe resorts of Europe or hunting grouse in the rural precincts of Britain, and Kate, a royal-in-waiting, would be no exception. But rarely are they seen powerfully piloting a Chinese dragon boat on the Thames. The date is January 8, 2007, and Kate (standing) is in training for a charity row with the Scion Sisterhood, a group of female athletes poised to become the first all-women crew to cross the English Channel—20 miles of open sea—in such a vessel. Her sisters in the 'hood will make a go of it, but Kate will leave the team before the event is staged due to, as a statement from the team put it, "security issues surrounding the recent media circus."

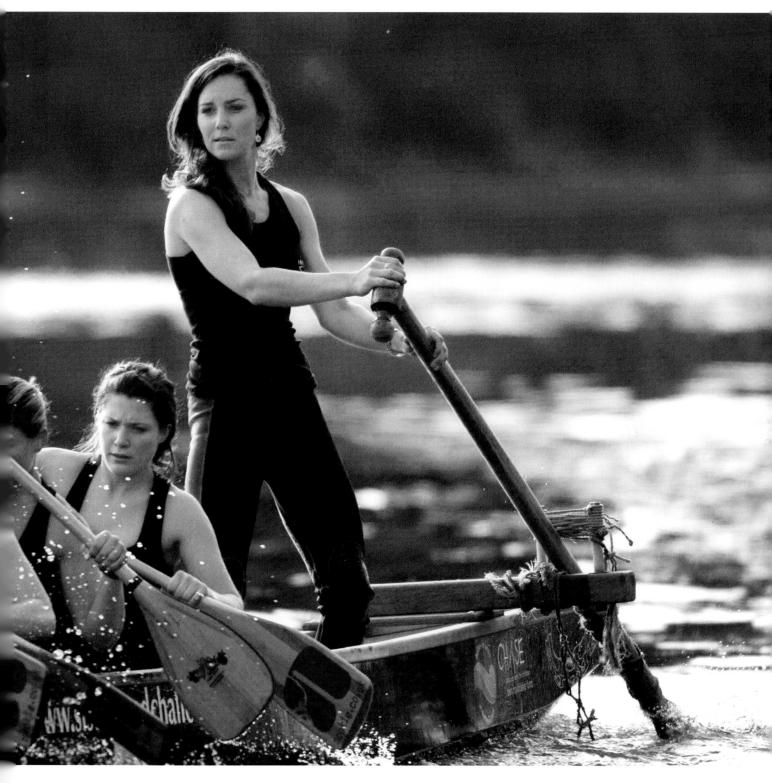

AN UNWELCOME PART OF THE JOB

Just as Kate was forced to withdraw from her dragon boat crew when the press pressed in, she has been badgered and beleaguered in everything she does—and forced to forgo other events she might have wanted to partake in—ever since she was first identified as The Royal Girlfriend (and Future Queen?). As celebrity watchers know, the media crush drove Lady Diana to distraction, and so it has been with Kate. The Palace pled for privacy and tried to enforce a blackout while Will and Kate were at St. Andrews, and Kate herself has complained publicly about the incivility of paparazzi. On occasion, William personally asked photographers to leave Kate alone, and in 2007 several British publications issued statements indicating that they would no longer publish paparazzi photographs of her. In the aftermath, the daily horde outside her Chelsea home decreased to only a couple of lensmen (below). A year later, Kate celebrated her 26th birthday at Kitts in Sloane Square, London (opposite). She faces, of course, a long lifetime of having her picture taken.

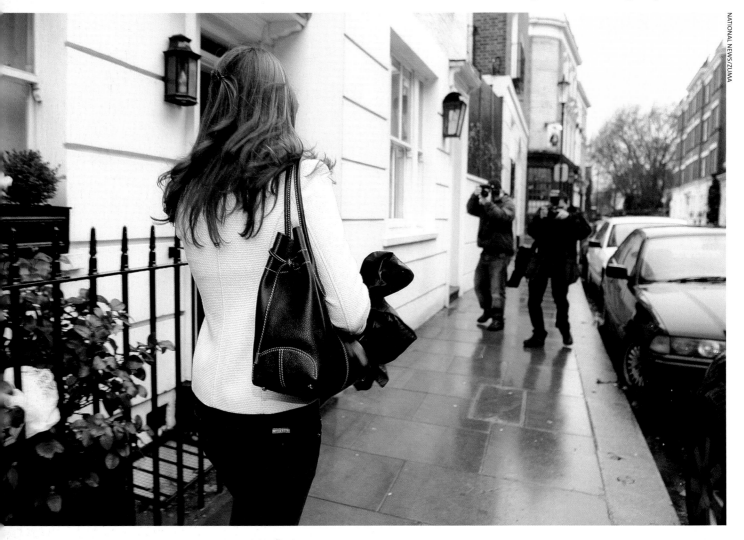

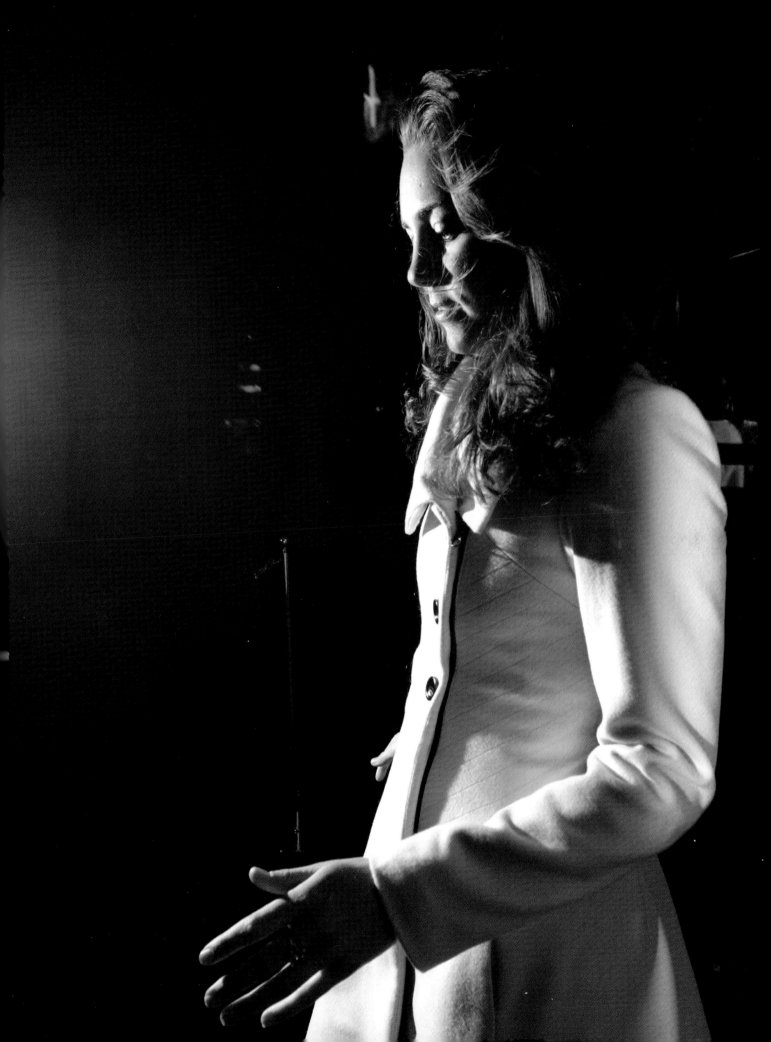

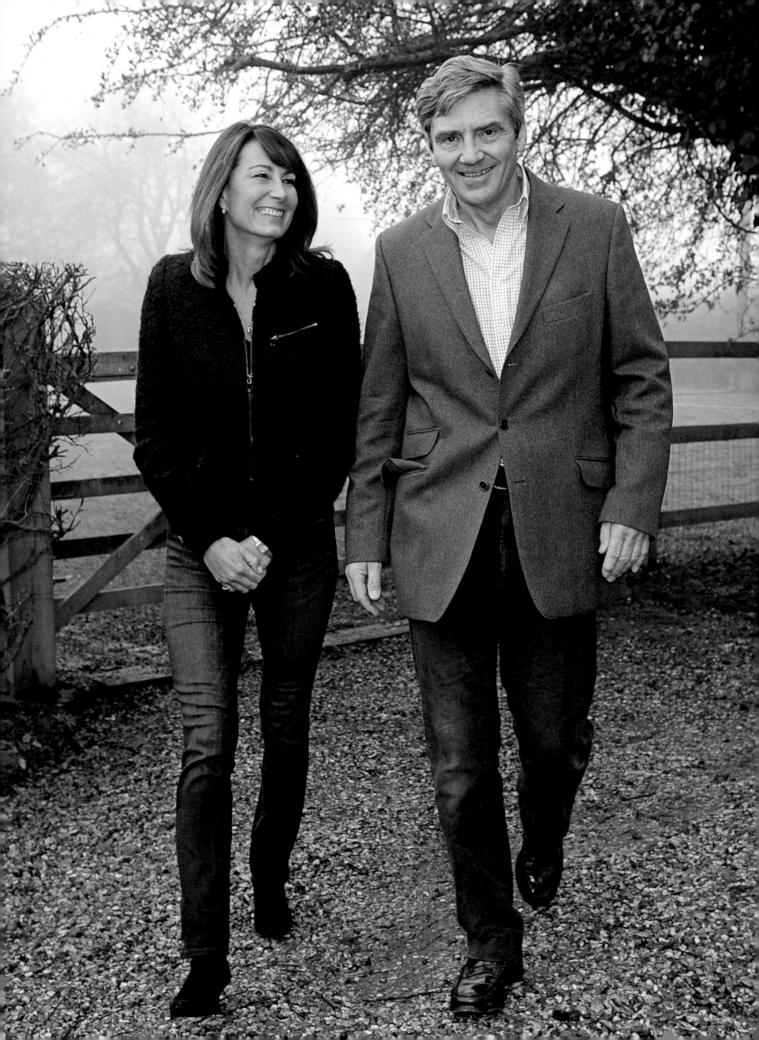

IV MEET THE MIDDLETONS

IF AUSTEN OR DICKENS HAD WRITTEN THIS ROMANCE, SHE OR HE WOULD HAVE called the family from which the bride emerged "the Middletons." The reader would have inferred immediately: *middle,* middle class, centered, something other than upper, and probably weightier, more grounded, more real. Kate could never have come from a family with a surname such as Kingsley or Royalton. The story wouldn't have worked so well.

The lineage on Kate's side is so very different from that on Will's. There are no fantastic marriages of convenience or politics made to alter world affairs; there are no headline-grabbing scandals (besides a wayward uncle); there is no Elizabeth or Victoria, there are no crowns or tiaras, there is no domestic drama at all, beyond the ordinary.

Whereas an interested party can move backward through Windsor history and learn lots about each and every individual, with the Middletons, the journey is quicker; and if the pickings seem slimmer at first, they ultimately amount to a heartening tale. The maternal family, the Harrisons, were working class, including several men who worked in the mines of County Durham. On the paternal side were folk from Leeds in West Yorkshire, including many who worked for the city or in commercial enterprises. Carole Elizabeth Goldsmith was born in 1955 and was a flight attendant when she met Michael Francis Middleton, who had been born in 1949 and was employed in the late 1970s as a flight dispatcher by British Airways. In 1980 the couple married at their parish church in Dorney in Buckinghamshire, and life was good. In 1982, Michael was made an airline officer at British Air, and the Middletons welcomed their first child, known from the get-go as Kate. Life became even better.

A couple of years on, Kate was followed by Philippa "Pippa" Charlotte Middleton and later by the girls' kid brother, James William. The family as it existed then might be described as somewhere between nuclear and antique. One could easily imagine Miss Marple solving a murder case in the Berkshire villages of Bradfield Southend and Bucklebury in southeastern England, or Thomas Hardy setting one of his fraught,

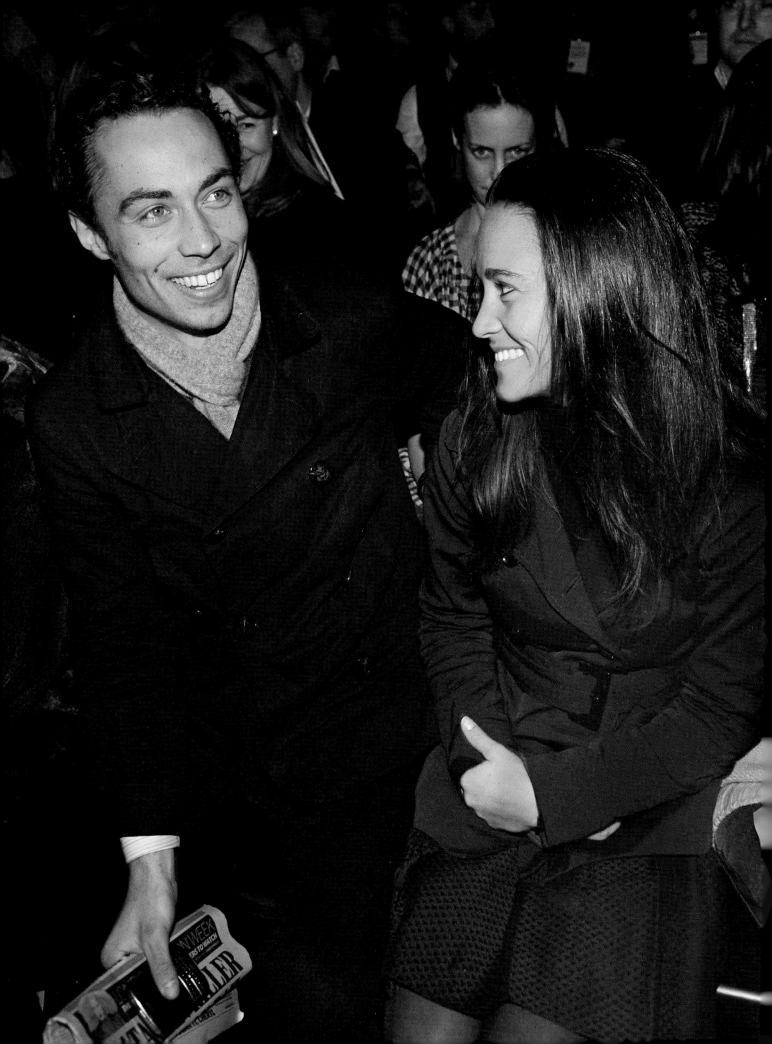

heath-and-heather epics there. The Middleton kids moved easily along the winding streets and shops of these towns, Pippa in particular becoming an outgoing youngster known to all. The parents were quietly ambitious, and in 1987, just when Kate was heading into her school years, they launched Party Pieces, an enterprise that marketed party supplies and decorations through the mail. It was a hit, and the Middletons were able to leave the airline industry behind in favor of a life as successful businessfolk and, soon thereafter, as multimillionaires—whether counting in dollars, euros or pounds. Money afforded opportunity, and Kate was educated at St. Andrew's School in nearby Pangbourne and then at Marlborough College in Wiltshire, which paved the way to the University of St. Andrews, which led to her meeting with a boy called Wills.

The Middletons, increasingly important in his life, were something new for William: a tightly knit, nonaristocratic, unsensational British family. It is questionable whether any earlier royal ever became so entrenched in the life of one of his or her subject's families. When he was training at the Royal Military Academy Sandhurst, in Surrey, serendipitously only 30 miles or so from Bucklebury, he would on regular occasion grab his motorcycle and hop on over for some hearth and home. The Middletons' door was always open, and they never pressed the issue of their daughter's relationship; they had supreme confidence in Kate. William, for his part, would jokingly call Michael Middleton "Dad." He certainly had no longing for a father figure; he and Prince Charles have always been close. But he just as surely relished the stability that was so tangible in the Middletons' sturdy brick house.

The personable Pippa Middleton has become something of a media personality as her sister's star has risen, and James, too, has become better known. He is fronting a party-goods business, tangential to his parents' supersuccessful endeavor, that focuses on cakes. But James made a faux pas, in the view of Buckingham Palace, when he sought publicity by baking a cake that depicted the face of Diana for a magazine feature. There have been other things with James, as we shall learn. With time, the siblings will forge their own paths, which will be distinct from, yet inevitably ever intertwined with, that of the Palace. The Middletons of Berkshire are now an inextricable part of London, too, and they are commoners no longer.

James, 22, and Pippa Middleton, 26, are as happy as can be at a show during London's fashion week in February 2010.

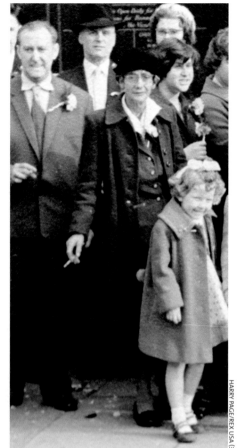

HARRY PAGE/REX USA (3)

UPWARDLY MOBILE

On this page: Kate's mom-to-be, five-year-old Carole Goldsmith, shows off her pretty smile in the photograph at center, taken in 1960. In the image at left is Carole's grandmother Edith Goldsmith, that same year. While some money did indeed descend upon the Middletons from ancestors even before Carole and Michael founded the family business, none of it came from Edith's line. She liked her cigarettes and was known to take a drink, but, toiling in a factory, she raised six children in Southall, a working-class west London precinct; often when she was at work, the older kids looked after the younger two, including Kate Middleton's grandfather Ronald. That is Ron, with his wife, Dorothy, in the picture on the right in June 1993. St. James the Less church in the small, 12th-century Berkshire village of Dorney is where Ron and Dorothy's daughter Carole wed Michael Middleton in 1980 (right). For the first 13 years of her life, Kate was raised in a comfy Victorian house called West View (opposite, top) in the Buckinghamshire village of Bradfield Southend. Her parents extended the kitchen and added a playroom while there, but once their family had grown to five, and their fortune had grown through the success of the Party Pieces enterprise, they moved two miles away to an estate in neighboring Bucklebury (bottom). To give an idea of the surrounding grounds: William made a well-remembered helicopter landing there in 2008.

MARK STEWART/CAMERA PRESS/RETNA

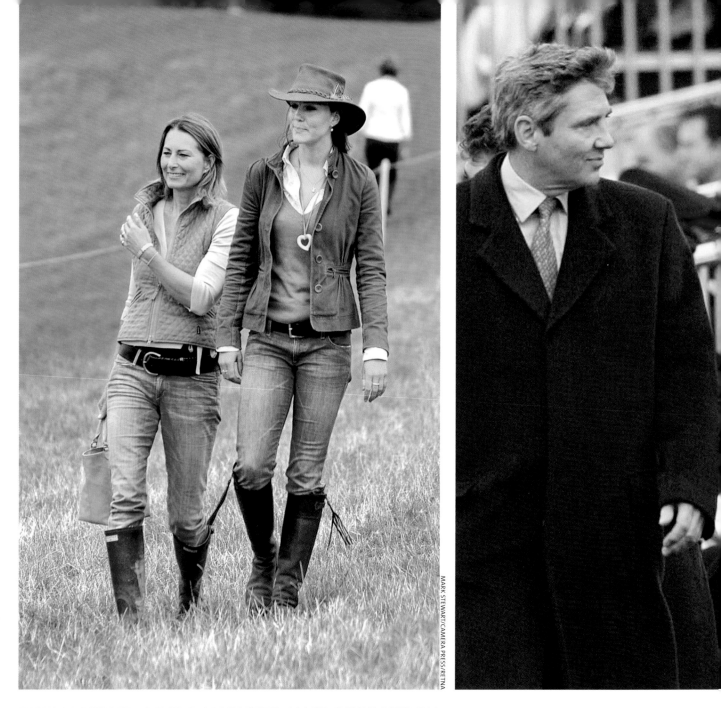

LIKE MOTHER, LIKE DAUGHTER (AND VICE VERSA)

Whether Kate has inherited her lovely mother's fashion instincts or whether, these last several years, Mom has taken clues and cues from her suddenly famous daughter is a question neither woman would be happy to answer. But both of them favor demure, tasteful clothes for the most part, and Kate is known to be dedicated to dresses by Issa (the very-highest-end designers are said to be frustrated that she seems reluctant to go way upscale). Above: Middleton mère et fille seen in an image taken in 2005 at Princess Anne's country estate, Gatcombe Park—an image that Ralph Lauren might applaud. Above, right: With Michael at the Sovereign's Parade at William's Sandhurst Military Academy in 2006. Opposite, far left: Shopping at the Spirit of Christmas Fair at the Olympia Exhibition Centre in London in 2005. And finally, two pictures of Carole that make you wonder if mother and daughter are not sharing a closet. In the center, she arrives at the Art for Starlight charity event at London's Saatchi Gallery on September 26, 2009. And, right, on June 19, 2010, she sports a bonnet at the final day of Royal Ascot that is the spitting image of one Kate wore to an earlier wedding.

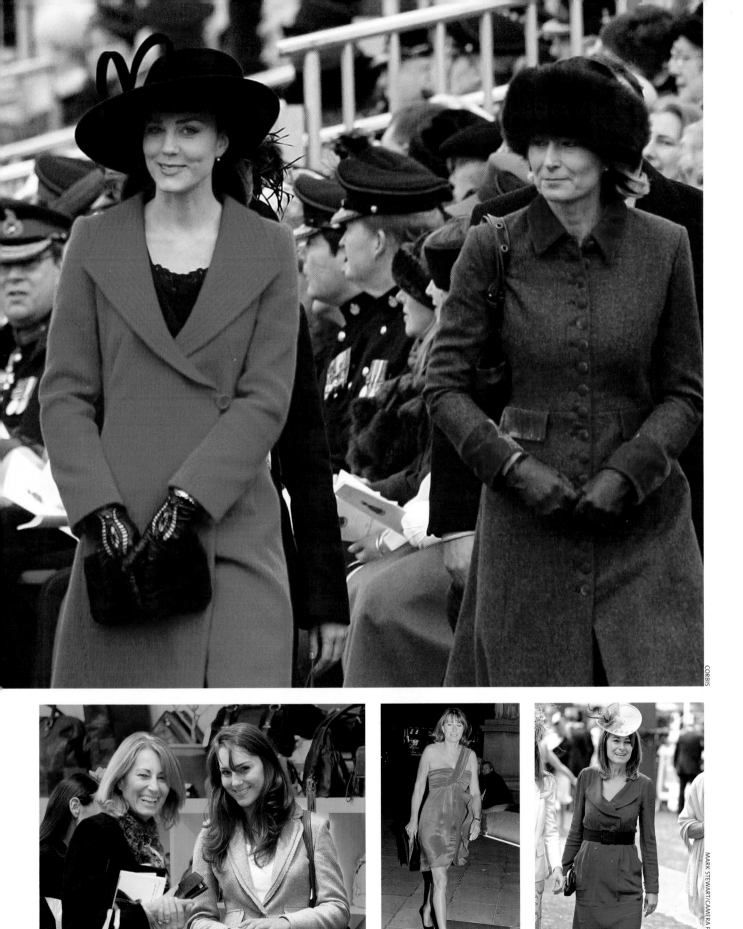

BIG SIS

Needless to say, Kate's celebrity during this past decade took her younger siblings for a spin as well. James, who might well be an usher in the wedding party, is seen heading with Kate to the Princess Diana Memorial Concert at Wembley Stadium in London on July 1, 2007. If the Middletons have anything approaching a black sheep in the family, James might be it. (Well, if we're talking about the extended clan, he's a lamb compared with Uncle Gary—Carole's brother—who lives high on the hog in Spain, and appeared, when caught in one of those London newspaper stings, to be an enthusiastic purveyor of drugs. We'll return to that ne'er-do-well, whose rise to tabloid prominence absolutely *thrilled* Buckingham Palace, on page 87.) A university dropout, James has made his way into the papers in pictures showing him evidently drunk. Whereas others in Kate's family routinely display the reticence hoped for by the Palace, James has given interviews promoting his professional career and is said to be sad when the paparazzi give him a miss. A new recent association has been with Forestry for Life, a firm that says it offers "lifestyle investments" and was under investigation last year by the City of London watchdog. Pippa, meanwhile (opposite, with Kate as they attend a book launch party on May 14, 2007), is seen as Most Likely to Be Bridesmaid. With her effervescent personality and upper-crust dating résumé, many had thought she would be, in fact, the first famous Middleton bride. As the *Daily Mail* wrote shortly after the November 2010 engagement of Will and Kate: "Ironically, family friends of the Middletons say that everyone always thought that the sparkly Pippa rather than the quieter and less glossy Kate would be the one most likely to make a spectacular marriage."

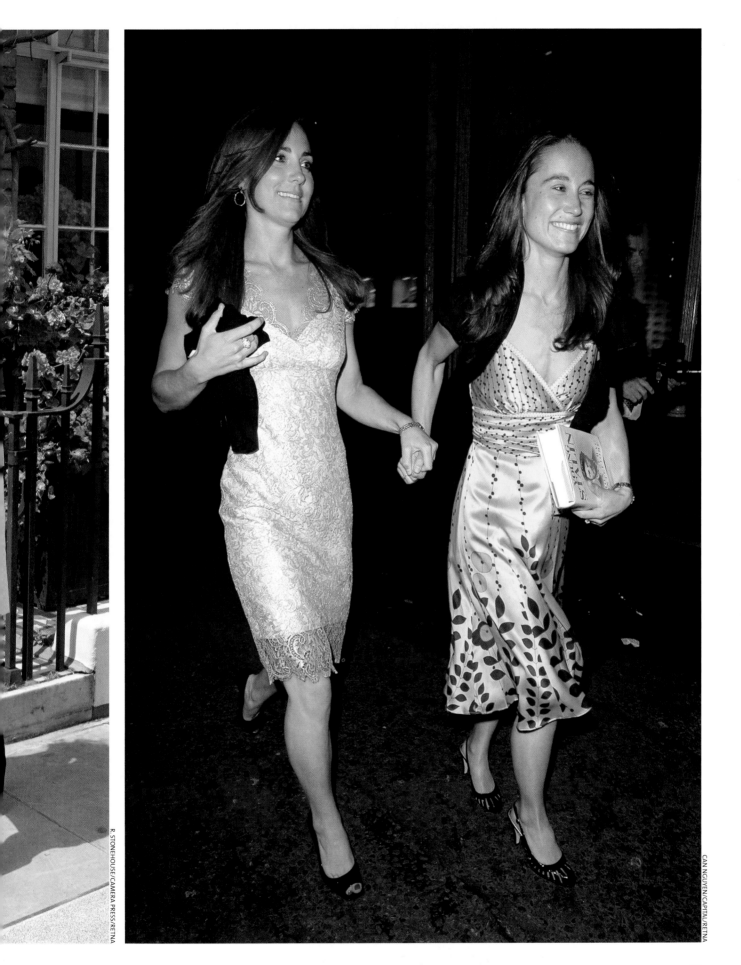

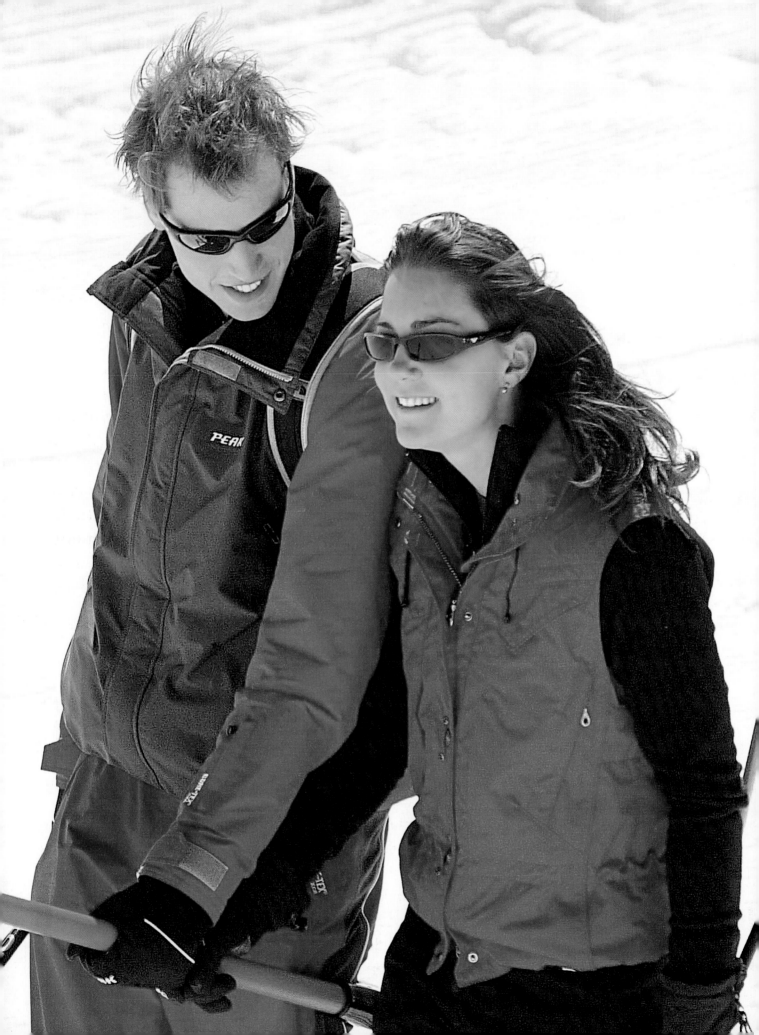

V THE COURTSHIP

As mentioned earlier in our pages, the legend has it that William first espied Kate Middleton in her underwear—during that undergraduate charity fashion show at St. Andrews. But legend is always more useful in writing a royal romance. Yes, William was in attendance that evening when Kate walked the walk. But the true start of their long courtship was quite a bit more innocent and charming, as the happy couple recounted in a television interview with Tom Bradby upon the occasion of their engagement in November of 2010. Bradby asked that they cast an eye back to the starting point, and William answered, beginning with a phrase agreed upon by all Britishers: "It's a long time ago now, Tom. I'm trying to wrack my brain about it all. We obviously met at university. At St. Andrews we were friends for over a year first and it just sort of blossomed from then on. We just spent more time with each other, had a good giggle, had lots of fun and realized we shared the same interests and just had a really good time.

"She's got a really naughty sense of humor, which kind of helps me because I've got a really dry sense of humor, so it was good fun, we had a really good laugh and then things happened."

Bradby asked: "Kate, what did you think of William. It's clearly not quite the same as meeting your average university student, or maybe it was. What was your first impression?"

"Well," said Kate, "I actually think I went bright red when I met you and sort of scuttled off, feeling very shy about meeting you. Actually William wasn't there for quite a bit of the time initially, he wasn't there for Freshers Week, so it did take a bit of time for us to get to know each other, but we did become very close friends from quite early on."

Indeed, said Bradby: "There's a story that goes around that you had a picture of him on your wall." William interjected, "There wasn't just one, there was about 20." But Kate was quick to counter: "He wishes. No, I had the Levis guy on my wall, not a picture of William, sorry."

The lovebirds share a lift at Switzerland's Klosters ski resort—long one of Prince Charles's favorites, now with a cable car to the top named *Prince of Wales*—in March 2004.

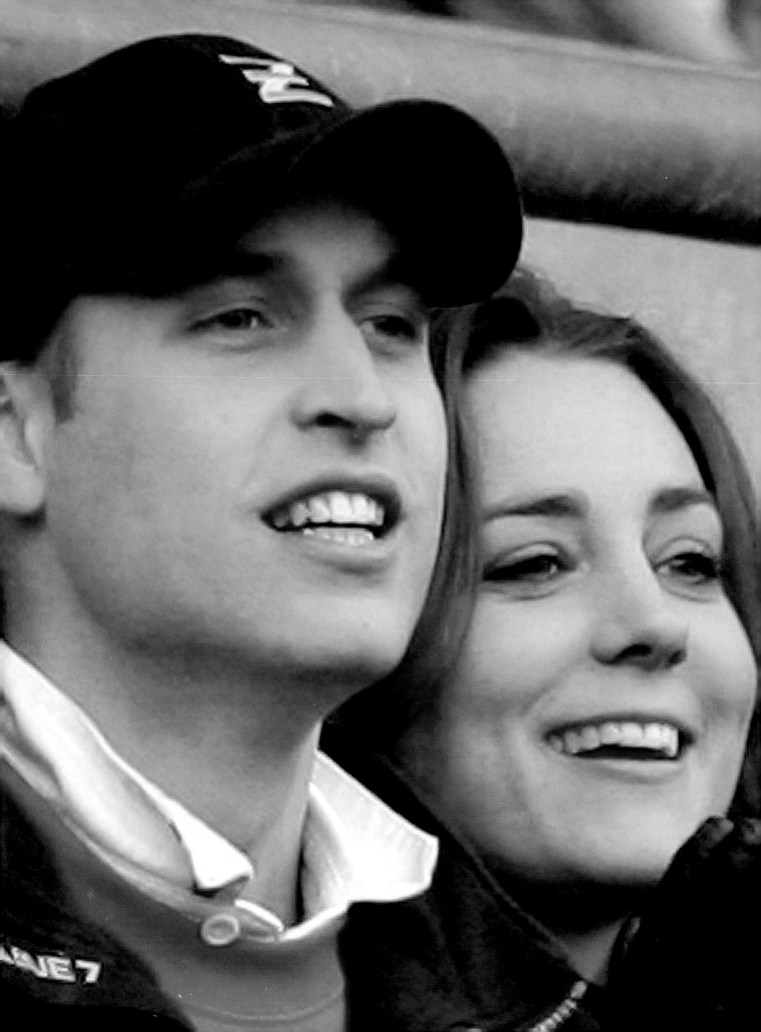

V THE COURTSHIP

William tried a riposte—"It was me in Levis, obviously"—but, point to Kate.

"You ended up in the same flat," said Bradby. "Was that, if you don't mind me asking, before you were going out?"

William answered: "No, we moved in together as friends because we were living together, we lived with a couple of others as well, it just sort of blossomed from there really. We just saw more of each other, hung out a bit more and did stuff . . ."

Bradby: "Slightly awkward for the other flatmates or okay?"

William: "No, to be honest, they were used to it, watching things catching fire, they found it very amusing."

The British people and others around the world watched things catch fire as well, and, not least because Kate seemed such a normal young woman, found it amusing, entertaining, attractive and romantic. Speculation that this was a love match made to last, and that a wedding might be in the offing, started several years ago and rarely abated, except for a period in 2007 when it became known that the couple had split. William has said of the protracted courtship that, because of the unwanted scrutiny that befalls a royal girlfriend, he wanted to afford Kate "a chance to back out if she needed to before it all got too much." Kate has said the time apart in '07 "made me a stronger person." Once the two reunited as lovebirds, the chattering classes all but demanded an engagement. Still, Will and Kate took their time. They were able to find a modicum of treasured privacy in Wales, where William was eventually stationed for military service, and grew ever closer. Kate continued to work for the family business, sometimes from afar, though she suffered tabloid criticism for not having a "real job." As William's mother had been forced to do, she responded to any catcalls with stoicism.

Wills and Kate must have started whispering to friends in 2010 that something was up, and the drumbeat toward betrothal grew louder, even unto in-the-know cover stories in *People* and other magazines. Finally, of course, everyone's waiting would be rewarded.

More sports: Will and Kate watch England vie with Italy in a Six Nations Rugby match at Twickenham Stadium in London in February 2007. This was just before they went through their short, famous breakup.

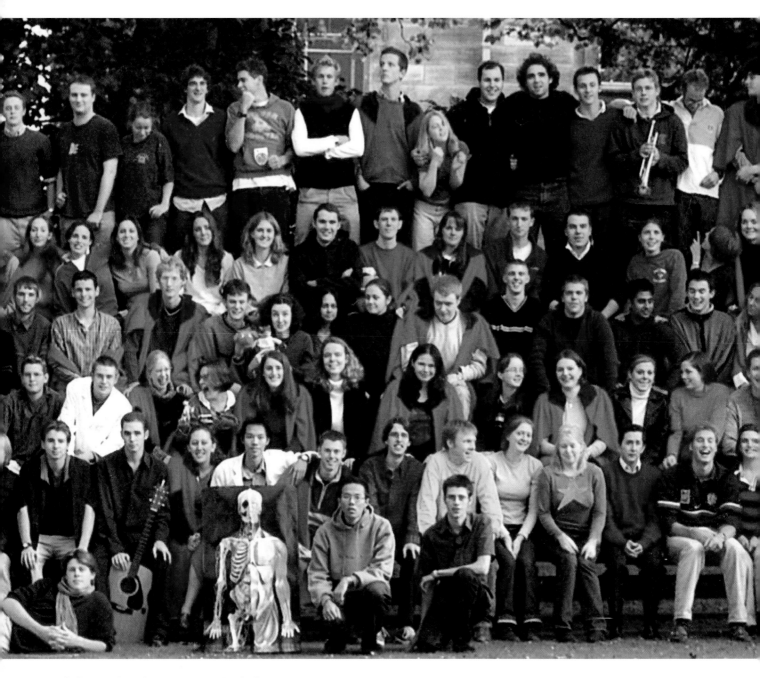

COLLEGE SWEETHEARTS

By May 2001, when the group portrait above was taken, Kate and Will have met in art class, he has gawked at her in that charity fashion show, but still these "close friends," who are living in the same residence hall, are not yet a couple as they join fellow first-year students for the fun picture. If Will, front row and fourth from right, or Kate, fourth row and fifth from left, knows what is to bloom this coming summer, neither is letting on. Shortly after the couple do get together, however, Will confides to friends that he is head over heels. Nevertheless, in those early years, he makes sure that they bury their relationship publicly, even unto semiofficial dictums against holding hands. Perhaps he is protecting her, perhaps he is adhering to Palace protocol. As late as 2007, when the happy photograph in the car (opposite) is made, Will and Kate are still reticent about advertising their love.

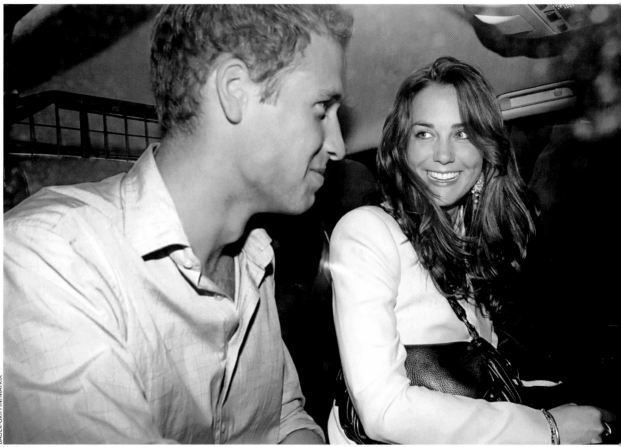

ON THE PLAYING FIELDS OF . . .

William's favorite form of polo is played in the water—the swimming kind, in which he competed at both Eton and St. Andrews. But of course his father, his brother and he are avid horsemen and polo players; it comes with the position. Below: William playing for Team Umbogo in the Chakravarty Cup match to benefit the Centrepoint charity at the Ham Polo Club in Richmond, London, on June 16, 2007. Kate would often be there to watch him compete, and they were many times seen together at other, higher level polo, soccer or rugby matches. Opposite: Will is comforted by Kate after being run 'round by the young 'uns. He has just played in an Eton Old Boys Field Game contest, in which the current crop of Etonians vie against alumni. The Field Game is a riff on soccer, one of a few Eton variations, including the famous Wall Game. In Field, the ball is round and to be kicked, but there is also a scrum called a "bully" and "flies" and three "behinds" playing to the rear of the bully. One can score "rouges" as well as goals, and there is no goalkeeper. It's all very Etonian, and to best understand it and its milieu, in which Will was very much at home, one should quickly consider: English school sports such as the Field and Wall games were the inspiration for J.K. Rowling's Quidditch.

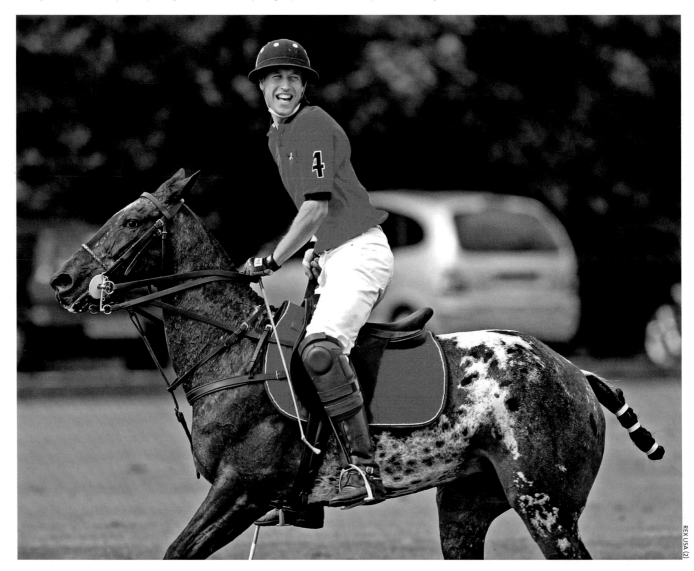

REX USA (2)

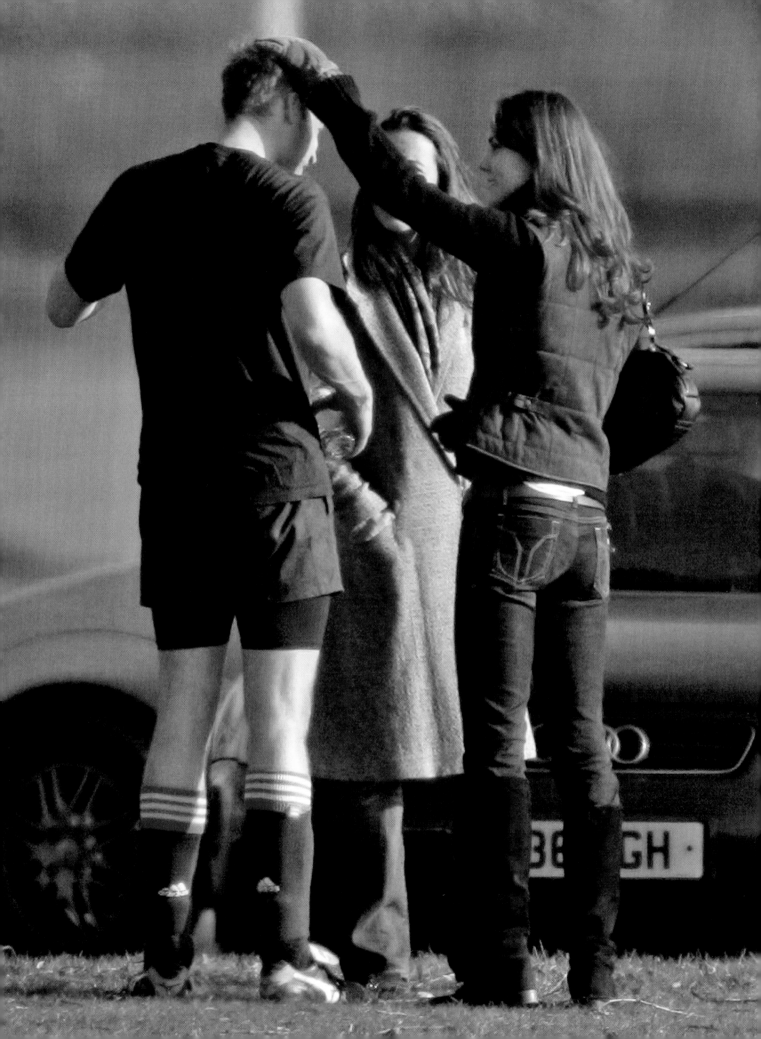

EVERYTHING SCRUTINIZED

When Will and Kate went skiing in March 2007 on the Swiss slopes of Zermatt (right), the tabloids wrote that "at an on-piste restaurant they stopped for a kiss and a cuddle . . . in the winter sun." That was breaking news; that was quite a scoop. The previous December, the newshounds also filed about hugging and kissing during a pheasant hunt in Windsor Great Park (below), a Christmas present to William (the day out being the present, not the hugging and kissing) from his grandmother the queen. This outing was seen as confirmation that the pair were firmly and emphatically back together as a couple, something implied by an earlier deer hunt in the Highlands surrounding Balmoral in which Kate had participated. Kate's fur hat at Windsor (was it real fur?!) was bad enough, but her suddenly routine participation in hunting put her on the hot seat with animal advocates. "It is shocking and abhorrent that she is engaging in blood sports," a spokesman for People for the Ethical Treatment of Animals said. "Kate is obviously trying to endear herself to the royal family and her decision will do her no favors whatsoever." Well, that remained to be seen.

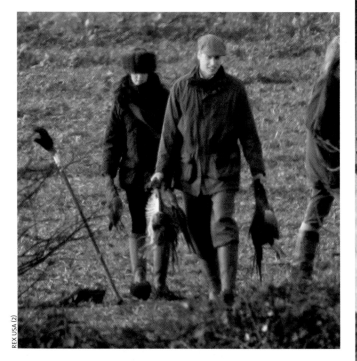

REX USA (2)

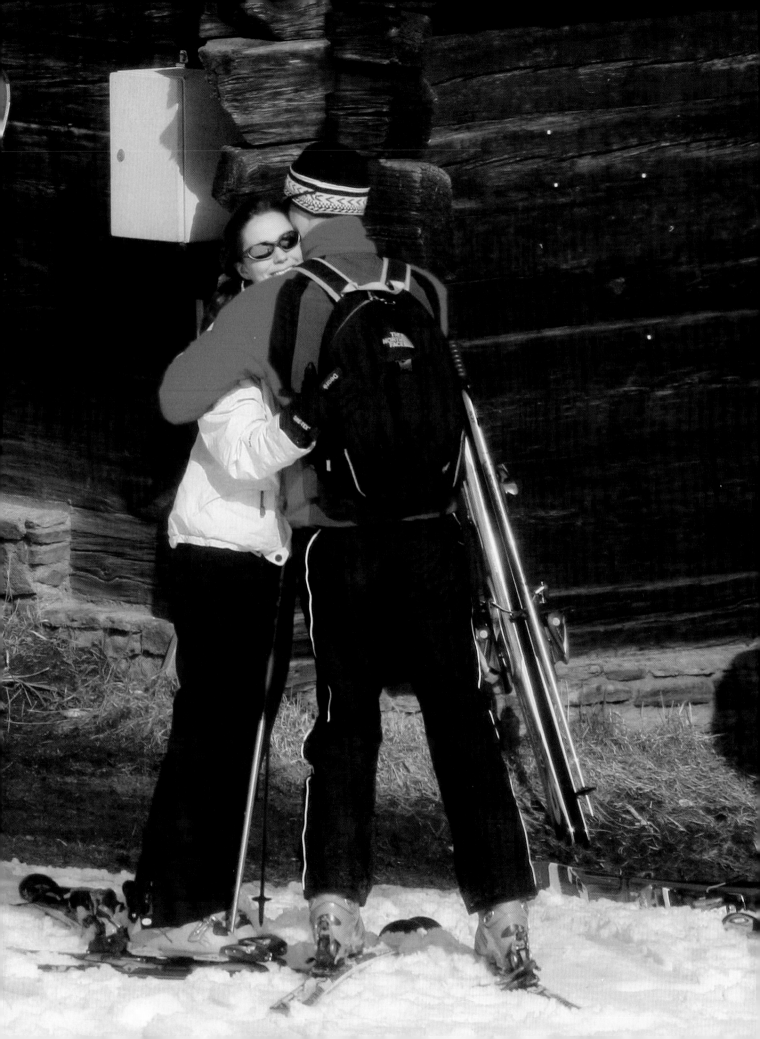

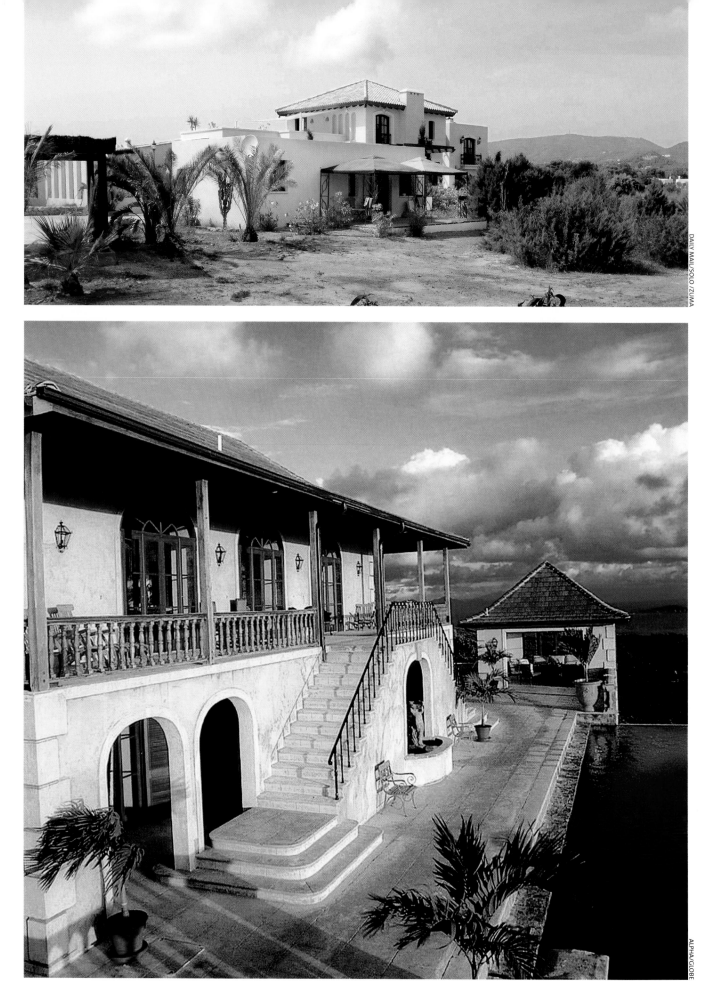

GETAWAYS

Considering the amount of energy the paparazzi put into ferreting out this young couple at every turn, it's remarkable that they were so often successful in finding private moments. Well, yes, crummy pictures, yielded by lenses so long they could bring detail to a crater on the moon, were splashed across tabloid front pages—"Kate Wears Bathing Suit on Boat!"—but when Will and Kate wanted to get away, they were able to get away. Of course, it helped build a wall when you booked 20 apartments, as they did during a weeklong stay at the Desroches Island Resort in the Seychelles in 2007 (top). Or when they went hyper-remote and private, like at the log cabin on the banks of the River Dee in Balmoral, where, in 2009, Will surprised Kate with a romantic candlelight dinner (left). On the opposite page are two other favorite haunts: At top is a white-walled villa on the Spanish island of Ibiza, to which they escaped in 2006. There they were hosted by the owner, Kate's uncle Gary Goldsmith, who had made millions in legit enterprises before being exposed by the *News of the World* as a lowlife. His villa, by the way, is named La Maison de Bang Bang, and translations from the French are available online. At bottom is the more felicitously named Villa Hibiscus on the tiny—and less troublesome—West Indian island of Mustique.

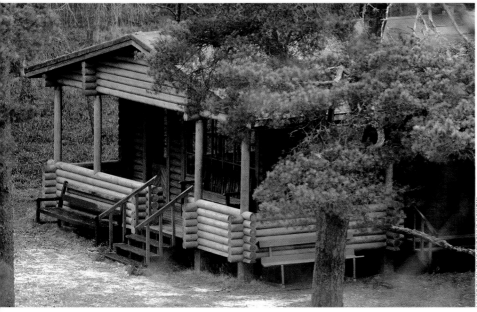

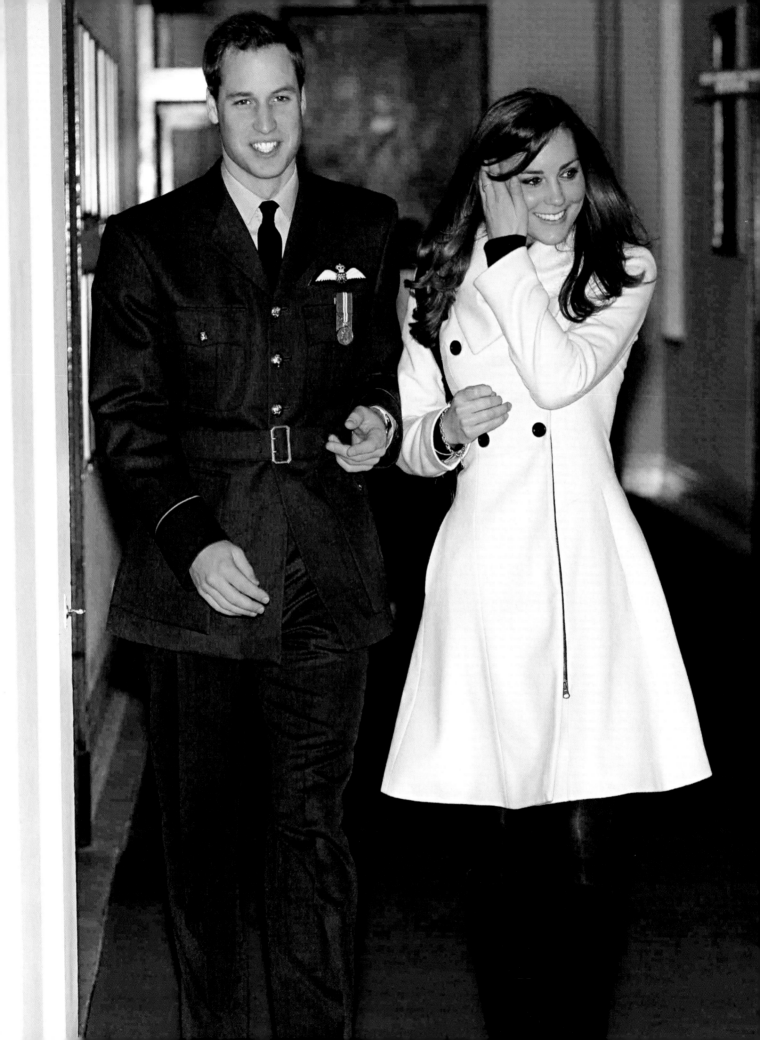

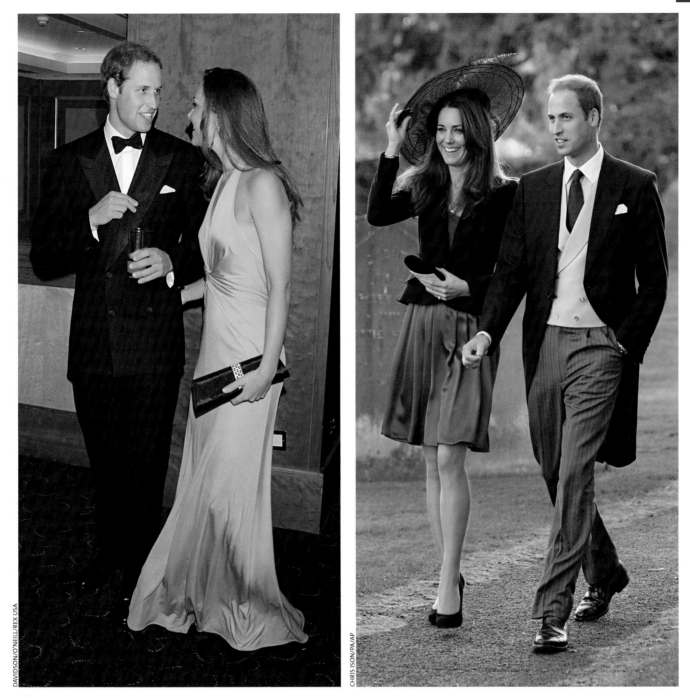

DAVIDSON/O'NEILL/REX USA

CHRIS ISON/PA/AP

STEPPIN' OUT

Opposite: On April 11, 2008, Kate is on hand as William gets his wings after graduating from the Royal Air Force College in Cranwell. All sorts of rumors were afloat that Kate would be banned from the ceremony by the Palace, as Queen Elizabeth had been put off by Carole Middleton's gum-chewing at William's earlier graduation from the Sandhurst Military Academy. Fences apparently mended? (It should be noted: Half the time the "news" of the queen's pique has her ire directed at Kate and half the time at Kate's mother, and sometimes the rumors, sourced anonymously from "inside the royal circle," are interchangeable.) Above, left: Kate is resplendent—well, they both are—at the Royal Lancaster Hotel in London on June 7, 2008. They are attending the Boodles Boxing Ball in support of the Starlight Children's Foundation, which is dedicated to brightening the lives of seriously and terminally ill children. Right: At the October 23, 2010, wedding of their friends Harry Meade and Rosie Bradford in the village of Northleach, Gloucestershire. This umpteenth "wedding of their friends" is just about the last straw for royals watchers, who are by now demanding to know what is up with these two? What the watchers didn't realize: Whatever might be up was already up, and all that remained was the public announcement.

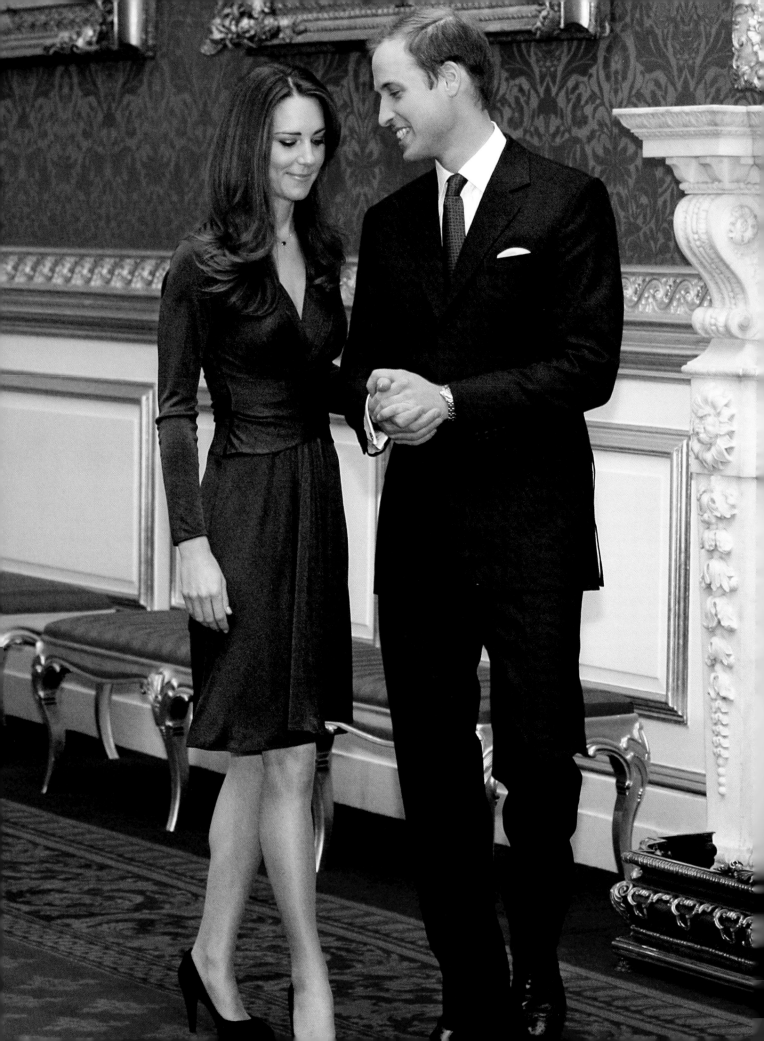

VI THE LADY SAYS, "YES"

CONSIDERING THAT THE BETROTHAL HAD BEEN BREATHLESSLY AWAITED FOR SOMEthing approaching a decade, the actual event seemed to fall out of the sky, taking London unawares. On a day in mid-November of 2010, Clarence House, the London home and headquarters of Charles, Prince of Wales, released a brief, succinct announcement that Will and Kate were engaged, that William's father was "delighted" and that a wedding was expected for the following spring or summer. Then the scrambling began in earnest, with camera crews rushing to Buckingham Palace, journalists angling for the big interview (it would be granted to William's friend Tom Bradby of ITV), reporters in the rural precincts descending on the Middleton estate in Bucklebury, where, at a prescribed moment in the midst of the furor, Michael and Carole stepped outside and he, working from a script, said: "Carole and I . . . are thrilled at the prospect of a wedding sometime next year. As you know, Catherine and Prince William have been going out together for quite a number of years, which is great for us, because we got to know William very well. We all think he's wonderful and we're extremely fond of him. They make a lovely couple, they're great fun to be with, we've had a lot of laughs together. We wish them every happiness for the future."

If the Palace, Clarence House, and Will and Kate themselves were trying to cast this historic moment of engagement in the most normal, day-to-day terms—*oh, well, but of course we're all delighted and thrilled and, well, you know*—the British and worldwide media weren't buying. Americans awoke to morning shows featuring pomp-and-circumstance music. TV segments and newspaper articles on potential royal gown-makers and the ascendancy of sapphires in the upcoming holiday gift period followed, and in England the Fleet Street press hammered home the royal-commoner angle that was so eternally fascinating—and important—to its readership. Representative was this passage, from Dominic Sandbrook, writing in the *Mail* and hearkening to 1821, when Kate's great-great-great-great-grandfather was at work in the mills of Hetton: "[W]hile James Harrison spent his life toiling underground in the horrifically dark and dangerous conditions of

At last! On Tuesday, November 16, 2010, with no advance warning—just the way the Palace likes it—the British press was summoned to St. James's Palace for a photo op to accompany the engagement announcement.

91

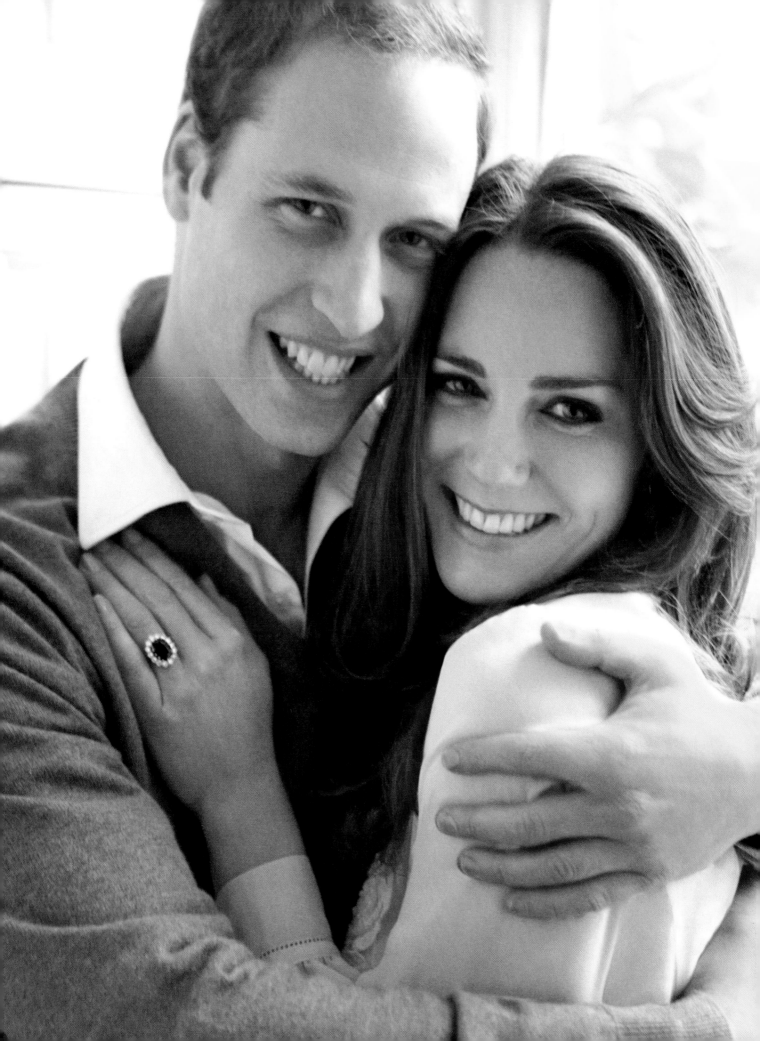

VI THE LADY SAYS, "YES"

the pit, William's great-great-great-great-great-uncle George IV was spending the equivalent of £4 million a year on wine and mistresses, becoming so fat he could barely stand.

"Had anyone told George that one day a future monarch would be engaged to James Harrison's direct descendant, the King would certainly have needed a drink."

George IV may have indeed demanded a gin or a gun, but be that as it may: The modern, savvy Wills and Kate seemed, to hash a few hoary metaphors, over the moon, two peas in a pod, happy as clams. They had been, as William put it, "talking about marriage for a while, so it wasn't a massively big surprise." Sweet stories trickled out as the betrothed and their confidants began to talk more freely.

The ring, for instance: It was, as we all now know, Diana's engagement ring, chosen by her—scandalously—from a catalog. It was valued back then at $42,000, a sum seen as unexorbitant if not modest. A sapphire in a ring of small diamonds, it was distinctive. Upon their mother's death, William and Harry each asked for certain keepsake items. Among other things, William received a special watch and Harry was given the ring. But when the engagement neared, the younger brother, who has long idolized William, grew certain that Diana's ring belonged on the finger of the woman who would one day be queen of England. William was glad to have it, and kept it secured for three weeks in his rucksack as he and Kate vacationed in Kenya in October of 2010 to celebrate his successful completion of the requirements to receive his RAF wings.

Africa has a special resonance for William; he considers it his second home, and, as it happened, his grandmother Elizabeth was on holiday in Kenya when she learned that her father, George VI, had passed away in England and that she was now queen. As William told Bradby: "I'd been planning it for a while but as every guy out there will know, it takes a certain amount of motivation to get yourself going. So I was planning it and then it just felt really right out in Africa. It was beautiful at the time. I just— I had done a little bit of planning to show my romantic side . . . You hear a lot of horror stories about proposing and things going horribly wrong. It went really, really well, and I was really pleased she said, 'Yes.'"

On page 30 we saw a warm Mario Testino black-and-white portrait of Charles and his boys, and Will obviously liked it, for Testino was chosen to make two official, equally loving color pictures to mark the engagement.

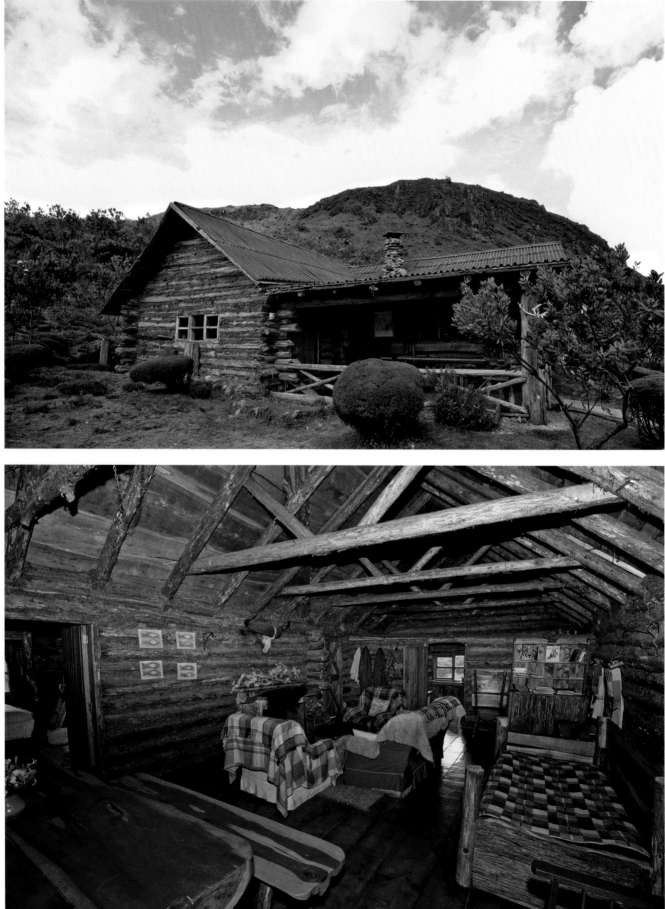

Well, this time, out of Africa came a couple betrothed. As mentioned in the introduction to this chapter, Africa is a special place—a magical realm—to William; a second homeland. He and Harry have gone there to volunteer and to represent the United Kingdom, and, again, their grandmother was staying at the Sagana Lodge in Kenya when she was called back to London in 1952 by news that her father had died and that she was already Queen Elizabeth II. For his part, William chose the Rutundu Log Cabins on a Kenyan preserve owned by the family of a friend: a woman once linked to him. Will and Kate billed this sojourn publicly as a vacation with a bunch of friends, but Will had that special ring in his rucksack and it is presumed that Kate, too, knew something was up. On October 20, they took a boat (not necessarily this one, left) out onto Lake Rutundu and William, as they say, popped the question. "It was very romantic," Kate would later recall. "There's a true romantic in there." They were oblique in the messages left in the cabin's guest book. "Thank you for such a wonderful 24 hours!" wrote Kate. "Looked after so well," offered Will. "Thanks you guys!" With their secret stashed away, they traveled back to London and prepared for the carefully orchestrated clamor of November 16. After Clarence House released the quiet engagement announcement, the volume increased throughout the city, especially at the State apartments of St. James's Palace (following pages), where the happy couple posed for pictures that would circle the globe at the metaphorical speed of light.

DAILY EXPRESS/ZUMA (3)

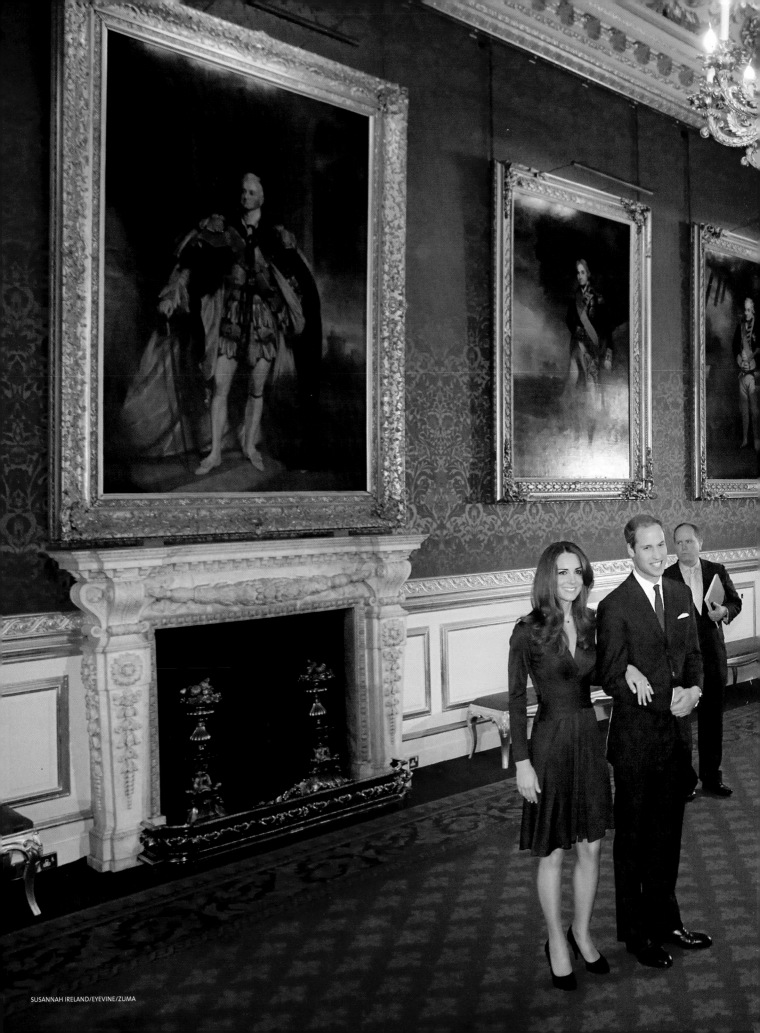

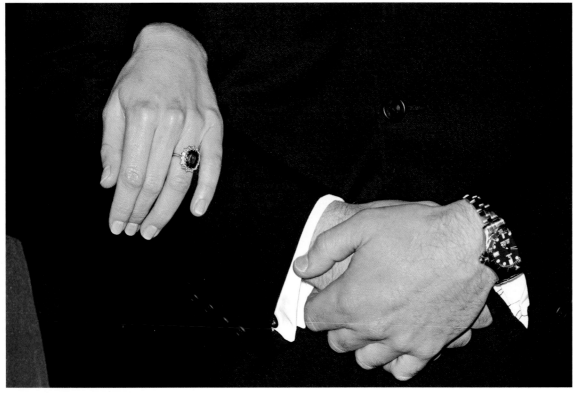

JOHN STILLWELL/PA AP

THE RETURN OF THE RING

Nothing on November 16 caused so much conversation as the choice of the ring, an 18-carat oval sapphire surrounded by diamonds that was once worn by Princess Diana (opposite) and that now graced the finger of Kate Middleton (above). Most people, knowing of William's affection for his late mother, agreed that this was exactly the right thing to do: the perfect note. When they heard the story about Harry offering it up, they were gladdened further. It's interesting that this time the ring drew such general applause, since first time around in 1981 it was considered a controversial choice—a choice famously not made by Prince Charles. It was called a "commoner's sapphire," and was valued back then at $42,000. Some folks, including some in the Palace, wondered why a future queen of England would not select something more opulent, at least something custom-made. But Diana knew her mind, and now this beautiful, tasteful ring comes to Kate. "I just hope I look after it," she said.

SNOWDON/GLOBE

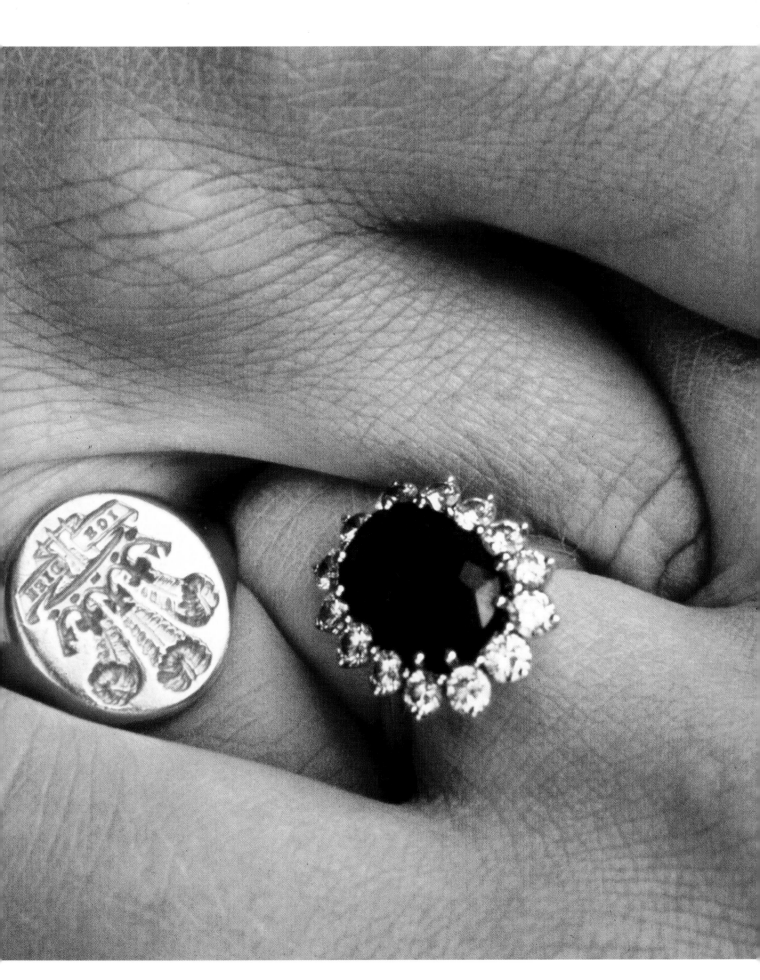

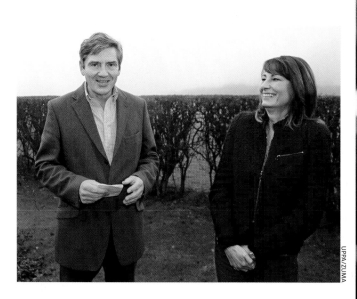

UPPA/ZUMA

HUZZAHS THROUGHOUT THE LAND!

ANDY RAIN/EPA/CORBIS

Carole and Michael Middleton had attended, earlier in November, the annual hunting party hosted by Prince William at Balmoral, and this was seen by many as the final evidence an engagement announcement was imminent: If the royals are inviting the parents, then the parents simply must be future in-laws. Within minutes of the Clarence House announcement, the London tabs were preparing their special evening editions (right), and within a few hours, cameras and reporters had descended on Bucklebury to hear from the Middletons. They emerged from their home on a chilly, foggy day, Michael with statement in hand (above). A Clarence House aide, dispatched from London, was present, whether to assist or intervene wasn't clear. It's fun, today, to watch the complete video of the Middletons' performance online. They're obviously happy, nervous and not used to this kind of thing at all. Michael goes to his notes regularly as he says how pleased everyone is, how it's good that the kids dated so long as they've gotten to know Will really well, how much they like him, how they're ready to have lots more laughs with Will and Kate in the future. "Don't need a retake?" Carole asks at the end. "You sure?" And so there it is: As the commoner is being taken into the royal family named Windsor, the prince is being welcomed by the Middletons of Bucklebury. Perfect. Now let's plan that wedding.

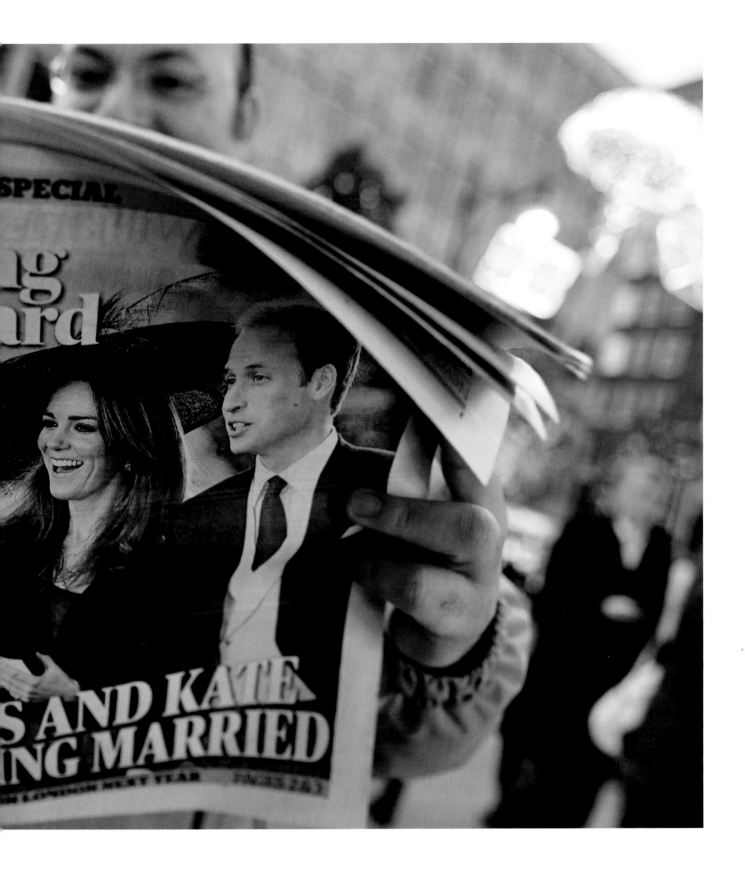

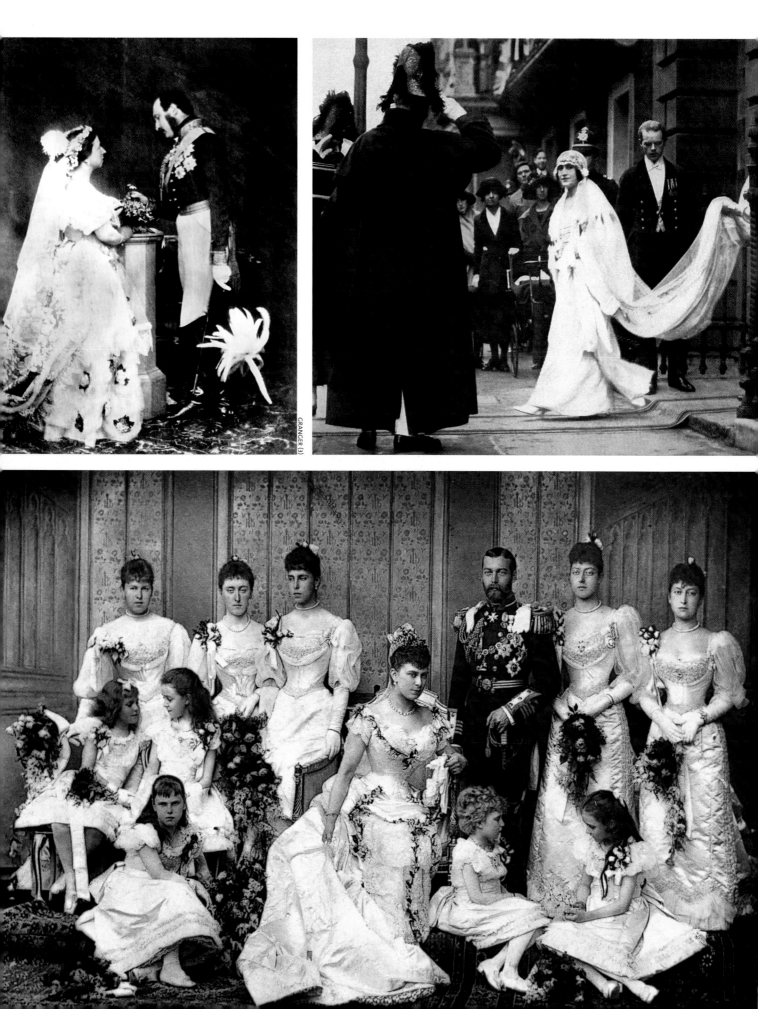

VII

ROYAL WEDDINGS THROUGH THE YEARS

CLEOPATRA AND ANTHONY MARRIED ON THE SUBLIME GREEK ISLAND OF SAMOS, and no doubt it was a splendid affair. Down through the years, the halls of Versailles in France were the setting for royal weddings of such opulence and ostentation as to hardly be believed. Marie Antoinette wed the Dauphin there in 1770—although it is lost to the mists of time whether she commanded, near the festivities' end, "Now, let them eat the cake."

In Japan, royal weddings are serious if not precisely somber matters, and the sacred moment when troths are pledged is a very private one. In England, by contrast, the tradition has long been that all the people are part of the pageantry, that everyone is invited and encouraged to raise a glass, even if not everyone can be fit into the front pew. Tens of thousands hailed Victoria and Albert more than a century and a half ago; millions throughout the United Kingdom cheered their descendant Charles and his Diana during the "wedding of the century" in 1981. And now, many millions and more will celebrate with Charles's elder son and his princess, Kate. It is predicted that this will be the biggest royal wedding of all time, costing more than $20 million. (Just by way of contrast, it will *not* be the most expensive society wedding ever: When Vanisha Mittal, daughter of an Indian steel magnate, married i-banker Amit Bhatia in 2004, the invitations included airplane tickets to Paris and reservations at a five-star hotel. There, five days' worth of complimentary Mouton Rothschild awaited along with individualized gift bags stuffed with jewels. The final tab came to $60 million.)

Twenty million, however, can buy a lot of wedding—and a bit of ribbing. Perhaps the best crack was Conan O'Brien's when he reported the supposed reaction of the father of the bride to the Palace's announcement that it would be footing the bill for the extravaganza: "Mr. Middleton said, 'You're goddamn right you will.'"

In fact, British taxpayers are on the hook for this latest extravagance in a storied line of them. But few among the hoi polloi have harrumphed. The man and woman in the street absolutely love this stuff. And always have.

Counterclockwise from upper left: Victoria and Albert; the 1893 wedding photograph of the future King George V and Queen Mary; Elizabeth Bowes-Lyon leaving her parents' London home in 1923 to travel to Westminster Abbey and be wed to George's second son, the Duke of York, who will become King George VI.

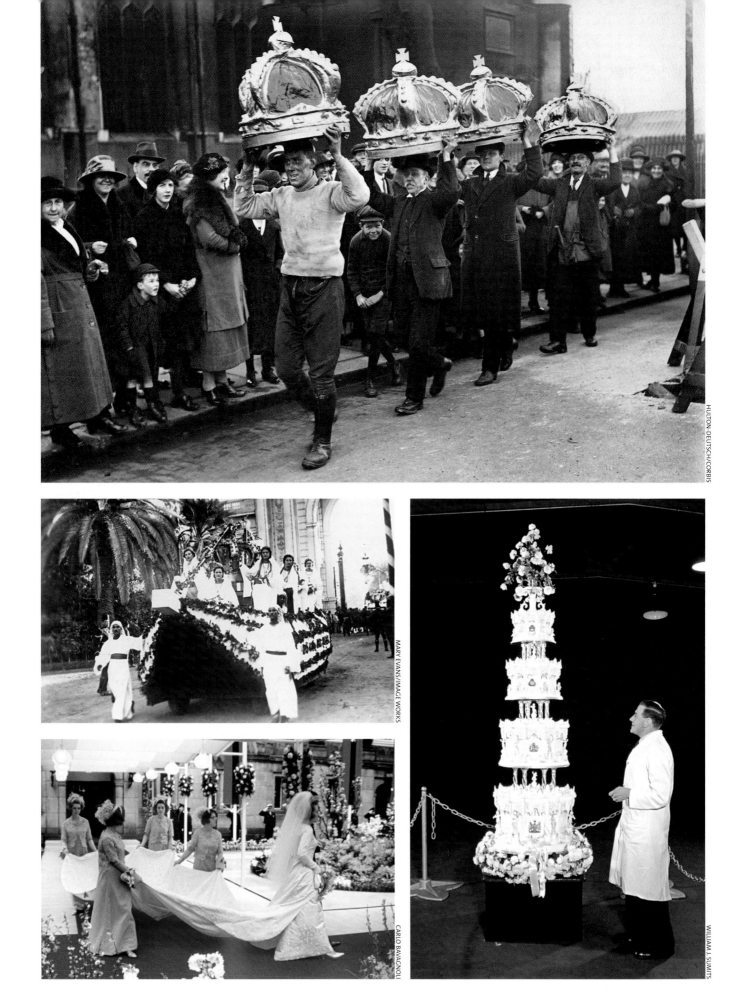

VII ROYAL WEDDINGS THROUGH THE YEARS

Clockwise from top: In 1922, large crowns are borne to Princess Mary's Westminster wedding; the royal wedding cake of Princess Elizabeth in 1947; the unwieldy train of Princess Beatrix of the Netherlands (on a day in 1966 that stirred massive protests as her betrothed was a former Hitler Youth); the ceremonial procession at the 1938 wedding of Farouk of Egypt and Safinaz Zulfikar.

When Tsar Nicholas II of Russia wed the German princess Alix of Hesse in 1894, it was a very big social, not to mention sociopolitical, deal. Same when Nicholas of Greece and Elena of Russia wed in 1902. And again when Juan of Spain married his Maria in 1935. When Grace Kelly of Hollywood married Prince Ranier III of Monaco in 1956 not only did the world ooh and aah in harmony, the press beat the term *fairy tale* to an absolute pulp.

There has been nothing, until now, like the wedding of Charles and Diana. All royal weddings since have been held in comparison. When, in 2010, Sweden's next queen, Crown Princess Victoria, married Daniel Westling in Stockholm Cathedral—with 1,200 royal guests and dignitaries attending, a half-million Swedes lining the streets and 500 million more watching on TV around the world—it was billed, proudly, as the grandest royal wedding "since that of Charles and Di." Tomorrow's comparison: "since that of Will and Kate."

There are so many ways to measure these grandiose celebrations: money, audience, weight of the jewelry, length of the train, sheer volume of the communal "hooray!" Number of presents is a fun one, too. When William's grandmother Queen Elizabeth married Prince Philip in 1947, also in Westminster Abbey, more than 2,500 wedding presents arrived from around the world, despite the fact that many nations had yet to recover from World War II. Charles and Diana wed during a global recession, but nonetheless, more than 4,000 gifts were sent to London; a fourth of them were put on public display for a period, and proved a very popular tourist attraction.

Records are made to be broken, and it is clear that, despite the fact that the Western world is hurting economically more than it has in 70 years, the flood of offerings that began in November of 2010 will, when all the tallying is done, eclipse that of Mum and Dad, and of Grandmum and Granddad.

As the pictures on these and the next several pages prove: Royal weddings are among life's most splendiferous affairs. William and Kate's royal wedding now joins the grand procession.

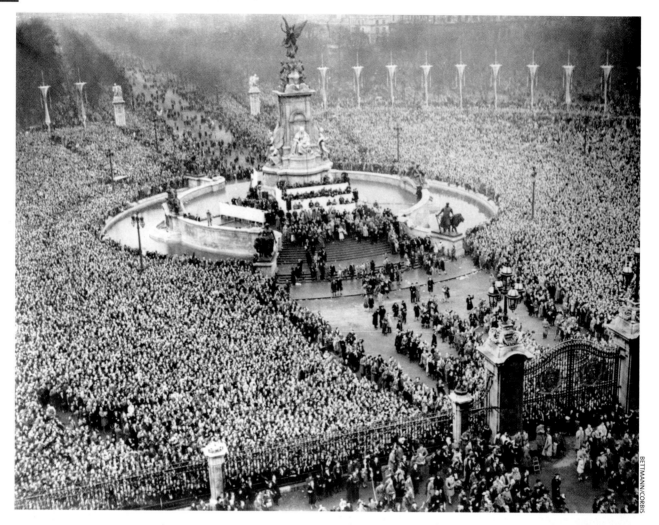

COME ONE, COME ALL

The rules of play at most royal weddings include this one: Everyone's invited. The people of any given monarchy are invested in their leaders, whether those leaders have real or merely ceremonial power, and they want at least a glimpse. Kate Middleton has already made one decision that will disappoint them: A modernist (and surely wanting to minimize comparisons to Diana on her wedding day), she will travel to Westminster on April 29 by car rather than in the storied Glass Coach. The hordes, which surely will dwarf in number the crowd that thronged the Victoria Memorial outside Buckingham Palace to welcome the newlywed Princess Elizabeth in 1947 (above), will, however, be able to greet Kate and Will as they cruise in the landau after the ceremony. At right are two more scenes from the wedding of the princess who would become Queen Elizabeth II: She walks the aisle at Westminster, and is happy indeed with Prince Philip by her side. Opposite: America's perfect big-screen princess, Grace Kelly, as she becomes Princess Grace of Monaco in 1956. The photo is a useful reminder: Beyond the glitz and beneath the glamour, accepting marriage is a solemn, spiritual act. This is often lost to the masses, and perhaps even to the participants, at a royal wedding.

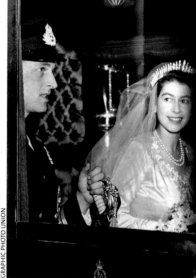

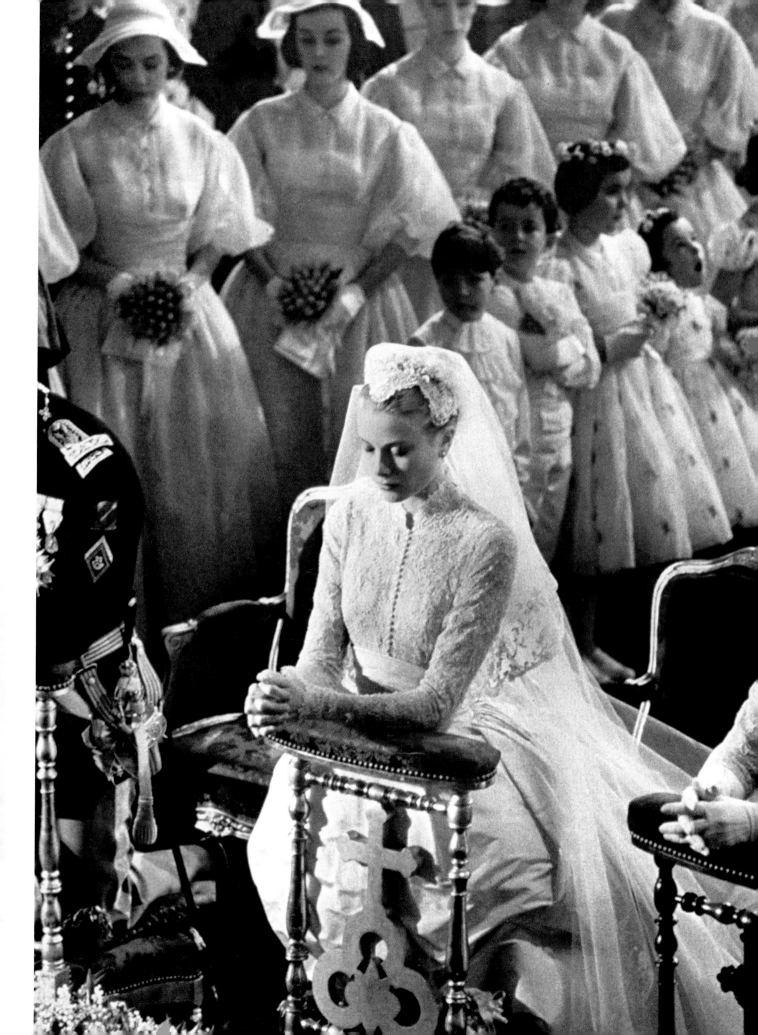

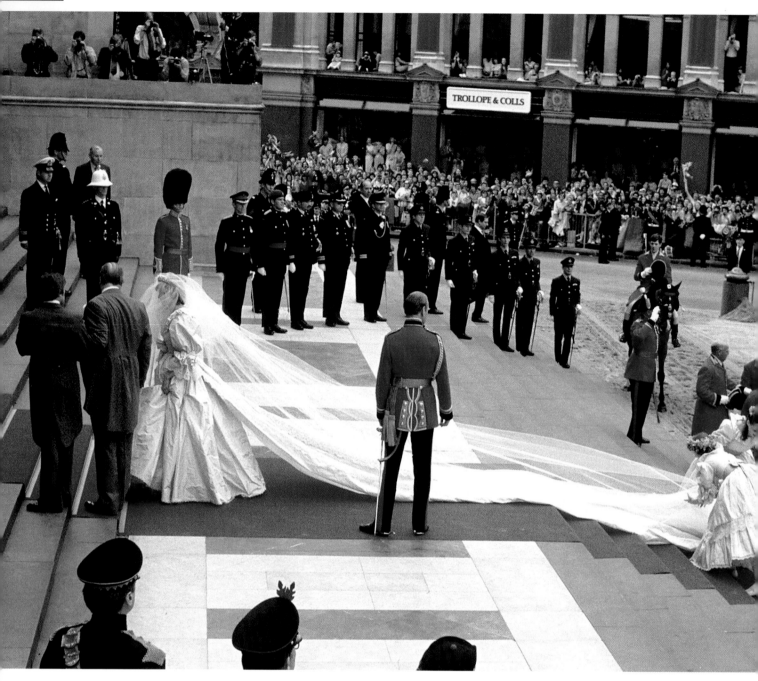

THE WEDDING OF THE CENTURY

Seven hundred and fifty million people worldwide watched 20-year-old Diana Spencer arrive at St. Paul's Cathedral in the Glass Coach on July 29, 1981 (opposite, top). They watched as Diana, wearing an exquisite dress with a 25-foot train, walked down the aisle, and they watched all of the supposedly private moments, as when Charles whispered encouraging words to his beloved (opposite, bottom right). They missed the really small moments that make a wedding day a wedding day. Thomas Patrick John Anson, the fifth Earl of Lichfield, would have been on the guest list anyway. But Patrick Lichfield, as the celebrity fashion photographer was more commonly known, was also commissioned to be the official documentarian. There were, of course, countless orchestrated portraits. In the aftermath, however, it became clear that the best picture of the entire day had been made when five-year-old Clementine Hambro—the great-granddaughter of Winston Churchill—bumped her head before being trotted out at the Buckingham Palace reception, and the solicitous Diana, newly a princess, leaned over to console her. Lichfield grabbed a simple little camera from his pocket, and the picture was made.

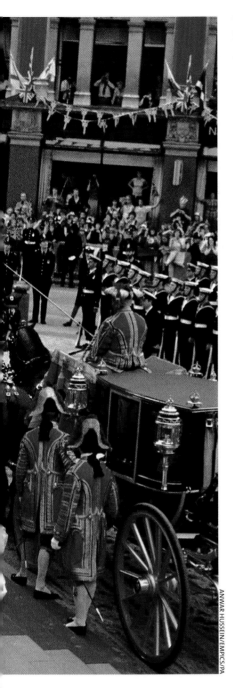

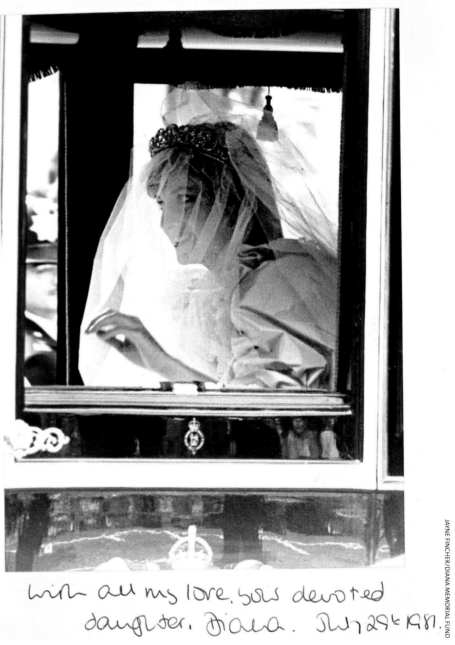

With all my love, your devoted
daughter, Diana. July 29th 1981.

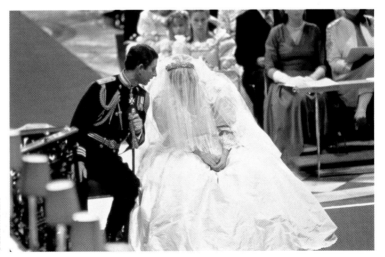

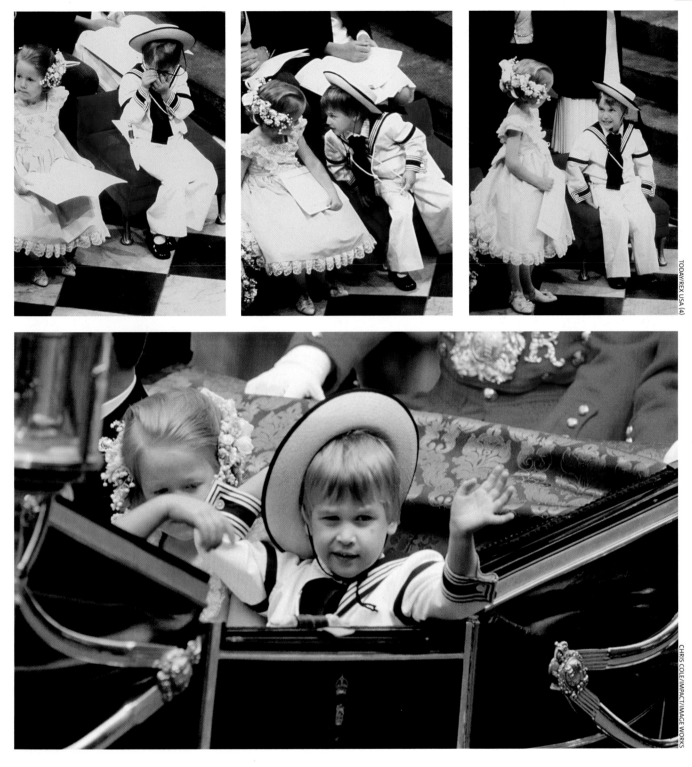

TODAY/REX USA (4)

CHRIS COLE//IMPACT//IMAGE WORKS

GAINING EXPERIENCE

Kate Middleton is, understandably, a novice when it comes to royal weddings. But Prince William is a quarter-century veteran. In 1986 at Westminster Abbey, he almost stole the show from his uncle Prince Andrew, Duke of York, and Andrew's bride, Sarah Ferguson (as if anyone could ever steal the show from the irrepressible, unsinkable Fergie!). In these pictures, the four-year-old Will's coconspirator in trying to inject the proper spirit into the day is Diana's niece, six-year-old Laura Fellowes. There are lessons to be learned here for Will and Kate as they build a memorable wedding, and wedding album. Among these lessons: Encourage stylish hats, pretty dresses, exuberance, playfulness, a bit of naughtiness, and a well-practiced wave. We presume that Will, fine student that he is, took good notes.

JUST ONE MORE

MATT DUNHAM/AP

NEVER ENOUGH PRINCESSES

On January 19, 2011—100 days and counting until the Wedding of the Century (So Far)—students from the Royal College of Art gather outside Buckingham Palace to show off their tribute engagement gowns, which they fashioned themselves, and compare their Kate/Di knockoff rings.